IMAGES
of America

STILLWATER

D1319060

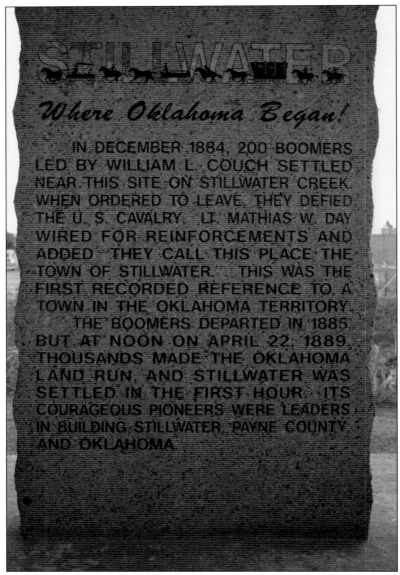

This granite marker reminds passersby where and why Oklahoma was opened for settlement. Because of the Boomers' location on Stillwater Creek, this was the battleground of would-be home seekers and the US Marshals. (Author's collection.)

ON THE COVER: This early-day photograph shows the hustle and bustle of Stillwater in the 1920s. Lytton Hardware (right) was a popular stop where residents bought much-needed items for building and maintaining their homes and farms. Today, Stillwater is a town of 45,000 and has earned its place as a vibrant and growing city. It seems each year another award is bestowed upon the city, which has been recognized as Oklahoma's Safest City, one of America's 100 Safest Cities, Oklahoma's Friendliest Town, one of America's Brainiest Cities, a Premiere Educational City (with one of Oklahoma's top school systems), one of America's top-six fastest-growing small cities, and a city offering the best quality of life, among other titles. (D. Earl Newsom.)

IMAGES
of America

STILLWATER

Stan Tucker
Foreword by Winfrey D. Houston

ARCADIA
PUBLISHING

Published by Arcadia Publishing
Charleston, South Carolina

Printed in the United States of America

Library of Congress Control Number: 2014941399

For all general information, please contact Arcadia Publishing:
Telephone 843-853-2070
Fax 843-853-0044
E-mail sales@arcadiapublishing.com
For customer service and orders:
Toll-Free 1-888-313-2665

Visit us on the Internet at www.arcadiapublishing.com

*Dedicated to my folks, Billy and Chris Tucker; my kids, Opie
and Annie Tucker; and my partner, Michael McDermott*

CONTENTS

FOREWORD

I have always been proud of my hometown on the Oklahoma Plains. I was born in Stillwater in 1926, and it has been my home ever since. My grandparents Dr. Campbell Rice and Nancy Frances Holbrook homesteaded west of Perkins in 1891. In 1910, they built a home at Tenth Avenue and Husband Street and moved to Stillwater.

I am the third generation of my family living in the area, and my great-grandchildren who live here make up the sixth generation. I have so many memories here that I do not have many surprises.

Part of my pride in being from Stillwater comes from its history. I believe the city that exists today would please its early leaders. It has a flourishing university that is a focal point for its residents. Main Street businesses thrive, and there is an entrepreneurial spirit that the town's founders would relate to and appreciate. After all, the very town exists because of their ingenuity.

Nothing came easily to Stillwater in the early days, as you will read on. Its status as a county seat and site of Oklahoma State University did not happen by accident. Rather, fueled by a hopeful vision of the town's future, residents employed shrewd—but ultimately effective— tactics to secure Stillwater's place as a hub for education and enterprise.

I hope you will find inspiration and entertainment in these pages. My thanks to Stan Tucker, a longtime friend of my family whose love for Stillwater is apparent, for writing this book that will tell our city's great story. Stillwater's history is not very glamorous, but I think you will agree it is beautiful.

—Winfrey David Houston

ACKNOWLEDGMENTS

This book would not have been possible without the support of many people. First of all, I thank the late D. Earl Newsom for his support and use of his amazing photograph collection, David Peters and Kay Bost from the Oklahoma State University (OSU) Library, Winfrey Houston for his encouragement and for writing the foreword, and computer whiz and friend Stacy Lueker. During the writing of the book, I had a great deal of supporters, including my kids, Opie and Annie (who also love Stillwater), my stepmom, Shirley Barbre Tucker, my sisters LaDonna Fuchs and Ann Wilkinson, the Sweetwater Tuckers, my McDermott family, Steve and Kelly Dilley, and Nancy Houston Beckstrom. I would also like to thank Kirk Lancaster (for the use of the ranch), Nani Pybus, Arturo "W.B." Callazo, Jarrod Houston Beckstrom, Phillip Brown (for his help photographing Stillwater), Charles Barraclough and Aimee Bryant from the Sheerar Museum of Stillwater History, Terry Taylor (for the Sonic information) and of course my partner, Michael McDermott, whose love of history has been contagious. I would not and could not have written this book without his love and support.

Unless otherwise noted, all images are courtesy of D. Earl Newsom.

Author's proceeds from the sale of this book will benefit the Pleasant Valley School Foundation and the Sheerar Museum of Stillwater History.

Introduction

The area that encompasses the Valley of Still Water was unknown to all but the Native Americans that possessed the land. They considered the sky their father and the earth their mother. They respected the land, as it gave them the necessities of life. They grew crops for food and hunted the buffalo for meat and hides. But while this land was the lifeblood of the Native Americans, it was also being coveted by land-hungry Europeans. While some were escaping the government's regulations, others just wanted freedom to do as they pleased. They saw this land as an opportunity to start anew and build new lives for their families.

In the year 1540, a century before Europeans set foot at Jamestown, the Southwest, including Oklahoma, was being discovered by Francisco Vasquez de Coronado, on an expedition representing Spain and an ill-fated search for gold, silver, and precious stones. On their trek between the fabled cities of Cibola, in present-day New Mexico, and Quivera, near present-day Wichita, Kansas, he and his party traveled through Oklahoma, entering from the Texas Panhandle between the Washita River and the Canadian River, through Roger Mills County.

Other explorers had traveled through the same area on the Old Spanish Road. This trail entered Oklahoma near present-day Sweetwater and went through Sayre, following the North Fork to the Red River, then east to present-day Lake Texoma in southern Oklahoma. Hernando de Soto and his expedition explored northeast Oklahoma from Sallisaw, following the Grand River north to the Missouri, Kansas, and Oklahoma border.

Trading began in earnest with the arrival of the French. Caddo Indians integrated with the French, trading their goods for guns and ammunitions. After some time, Caddos and Frenchmen married; thus, the French considered Caddos, along with some other tribes, their subjects. More active trading was being developed as a result of the arrival of Bernard de la Harpe in 1719. Other expeditions by Mallet and LaBruyere created even more trade and cemented the relationship between the newly arrived Europeans and the natives.

The late 1700s brought nervous tension between the new American republic and the Napoleonic French on the western side of the Mississippi River. The United States of America needed control of the Mississippi, and Napoleon needed money. Through some good fortune and bargaining on both sides, Pres. Thomas Jefferson agreed to the Louisiana Purchase for a cost of $15 million.

In 1832, American writer Washington Irving toured the area, coming through the Still Water Valley, and wrote about it in his book *A Tour on the Prairies*. This was the beginning of the quest for white settlement in the Unassigned Lands of the territories. The area, which now encompasses Stillwater, lies in the center of this land. While the Five Civilized Tribes from Tennessee, Georgia, Florida, North Carolina, Alabama, and Mississippi were moved against their will along the Trail of Tears, they were given lands in present-day Oklahoma. The Unassigned Lands were set aside by the federal government for the nomadic tribes that roamed the plains. Some of the other nearby tribes were the Osage, Kaw, Otoe-Missouria, Ponca, Iowa, Pawnee, Pottawatomie, and the Sac and Fox.

All these events set the stage for the next chapter in Oklahoma's history. The Boomer movement, whereby white settlers moved into the Unassigned Lands near present-day Stillwater, drew national attention to the need for opening the area to settlement.

This led to the Great Land Run of 1889, one of the most important events in the nation's history. While some towns along the railroads gained thousands, Stillwater only garnered a handful. Overnight, Guthrie, Norman, and Oklahoma City each reached a population of more than 10,000. Four years later, Perry, 25 miles northeast of Stillwater, became a city of 30,000 overnight. By this time, Stillwater had grown to 1,200, but it would lose half of its population in the 1893 Cherokee Strip Run.

The group that stayed might have been small, but they were determined. With few amenities, the residents were hardy and tough, and the town grew slowly but steadily. Although some towns'

populations grew rapidly by the thousands, Stillwater was different; lacking railroads, residents often thought outside the box to survive. These new residents were complete strangers and had to learn to work together to build the town they had envisioned.

Their first year was hard. Because of a major drought, they struggled to grow vegetables and feed for their stock. The only crops that seemed to grow were turnips. Thus that first year became known as "the Year of the Turnips."

The fight for the county seat and the battle to be selected the site of the new land-grant college, Oklahoma Agricultural & Mechanical College (OAMC), both cemented Stillwater as a permanent city. To gain the county seat and the college required the leaders to outsmart other communities.

The following years were fruitful, as the town grew steadily. While other nearby towns, such as Perry (formerly known as Wharton), took one day to reach a population of 30,000 because of their location in the Cherokee Strip Land Run, Stillwater took over 100 years.

But that steady growth proved to be the best way for a city to survive. By retaining both the county seat and the college, Stillwater was now able to turn its sights to building upon those assets. Attracting shopkeepers, doctors, attorneys, churches, and more became much easier when, in 1900, the railroad finally made its way to the community. This was followed in the coming years by new industry to compliment the college and its workforce.

Today, Stillwater boasts a population of over 45,000. Oklahoma Agricultural & Mechanical College became Oklahoma State University in 1957, and there are now more than 23,000 students on the Stillwater campus. The city's largest employer is also OSU, with over 6,000 on its payroll. Stillwater Medical Center has become a regional hospital providing medical services for all of north-central Oklahoma, and it employs almost 1,000 people. The school system now comprises 10 schools, with approximately 750 employees on its payroll. Other industries include Armstrong Flooring Company, National Standard, Stillwater Designs/Kicker (making high-end automobile audio equipment), and Asco Industries, which manufactures parts for the aerospace industry.

Stillwater is also the world headquarters of Eskimo Joe's, a restaurant and clothing store that has been Oklahoma's No. 1 tourist attraction. Eskimo Joe's boasts the second-best-selling T-shirt in America. This coupled with the ever-growing campus of OSU, whose newly revamped Boone Pickens Stadium holds over 60,000 Cowboy fans, keeps Stillwater an active and growing city.

The dream of the early pioneers has paid off, and Stillwater is a place that people are proud to call home.

One

A GLORIOUS PRAIRIE
THE VALLEY OF STILL WATER

While most people relate the founding of Stillwater to the Great Land Run of 1889, the first words about the area were penned 57 years earlier by the famous writer and explorer Washington Irving. A master of the short story—with his works including "Rip Van Winkle" and "The Legend of Sleepy Hollow"—Irving became America's first international literary celebrity. After many years in Europe, he returned to embark upon a new and great adventure. At age 49, he would travel to the area now known as Oklahoma to write his book *A Tour on the Prairies*. With a group of adventuresome travelers, he set out on an expedition through an unknown and mysterious land, part of the Louisiana Purchase. Irving first camped just north of present-day Ripley, Oklahoma (11 miles southwest of present-day Stillwater). He described a "singular crest of broken rocks resembling a ruined fortress," which reminded him of a Moorish castle. Today, that rocky outcrop is known as "Washington Irving's Castle." On October 21, 1832, he came upon the Still Water Valley. He then wrote, "We now came out upon a vast and glorious prairie spreading out beneath the golden beams of the autumnal sun. The deep and frequent traces of buffalo, showed it to be one of their favorite grazing grounds."

He may have encountered some of the tribes, including the Sac and Fox, Otoe-Missouria, Pawnee, and others, roaming the land for buffalo, which they used as a source for food, clothing, and shelter. Some of these Native Americans had recently been forced from their ancestral homelands in other parts of the country.

After a life of writing comedic stories using pseudonyms such as Jonathan Oldstyle, Dietrich Knickerbocker, and Geoffrey Crayon, Irving settled along the Hudson River in Tarrytown, New York, on an estate he named Sunnyside. There, he wrote *A Tour on the Prairies* to provide Easterners and Europeans their very first account of what life in the American West was actually like.

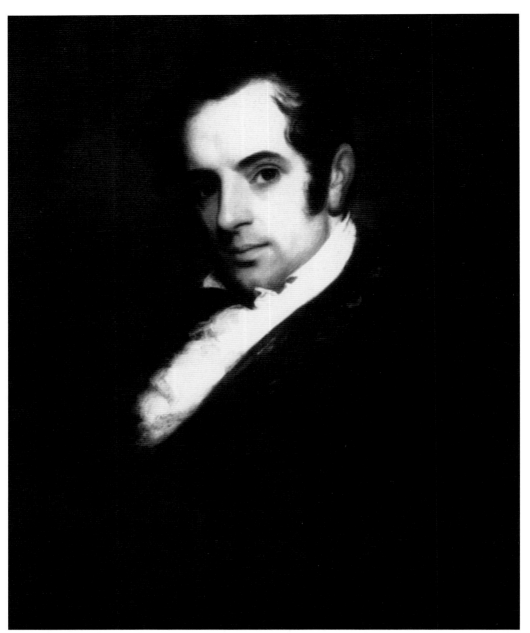

When Washington Irving first arrived south of the Still Water Valley, he wrote that it was "a deep stream running along the bottom of a thickly wooded ravine." Thickly wooded may have been an understatement. The banks of the clear creek, which had not been named, were beautiful, filled with fruit and pecan trees, wild grapevines, thickets, and brambles. Irving and his contingency searched for the best place to cross the deep creek. The group found a small opening and began their trek across the water. Several of the men on horseback fell in, causing a bit of chaos for the group. Irving himself was actually caught by a large wild grapevine, which caused him to fall from his horse. He wrote later that the event was such a comedy of errors that the group spent time laughing about the situation rather than feeling defeated by the creek.

Washington Irving came from his home in New York to join a contingency of explorers and document frontier life in the West for his upcoming book, *A Tour on the Prairies*. He started his Indian Territory expedition from the Arkansas River at Fort Gibson, following the Cimarron River (then known as the Red Fork of the Arkansas). This led the group to the Stillwater area on October 20, 1832.

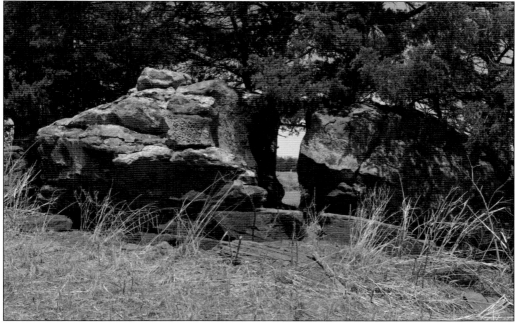

Washington Irving's camp location sat near an unusual site. It was a hill with large boulder outcroppings, and there were naturally stacked rocks that Irving described as a "Moorish castle" and called "Cliff Castle." The 1899 owner, David Sherrill, unaware of Irving's journey, removed many of the boulders to line his farm pond. He failed to notice the petroglyphs carved into many of the rocks. At a later point in Irving's journey, the group captured a wild horse, and Irving named the nearby creek Wild Horse Creek. (Author's collection.)

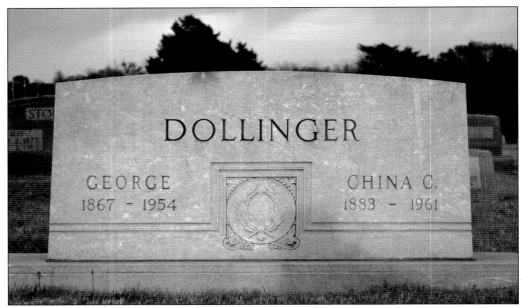

It was 1895, and George Dollinger was the first to file a homestead on the land where Irving had camped and that Irving had called Cliff Castle. Dollinger became postmaster of Ingalls, Oklahoma. After four years of never living on the property, he sold it for $400 to David Sherrill. The Sherrill family owned the farm for 32 years before learning of its historical value by reading Washington Irving's A *Tour on the Prairies*. In the late 1980s, the Daughters of the American Revolution were instrumental in obtaining a historical marker on Bethel Road east of Stillwater. George Dollinger's homestead certificate was actually signed by Pres. Grover Cleveland on July 25, 1895. Below is the view from Washington Irving's camp, looking east towards the Still Water Valley. This would have been his view when writing that this must have been a favorite grazing ground for buffalo. (Both, author's collection.)

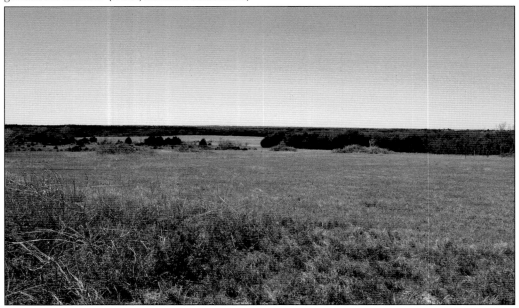

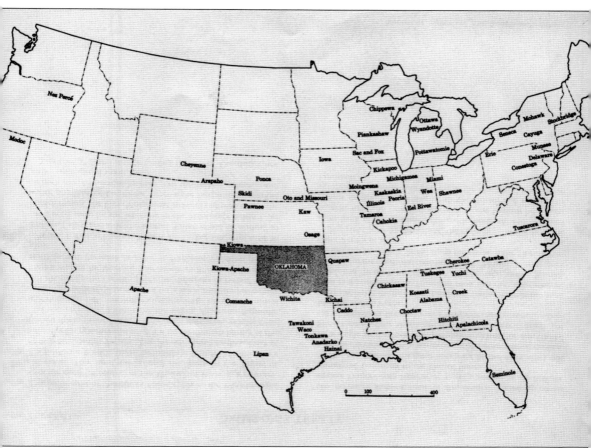

There was a time when the area that is now Oklahoma was considered as a site to which all African Americans could be moved. Obviously, that did not materialize, but the region did become the territory for Native Americans following several treaties with various tribes starting in 1827 and the Indian Removal Act of 1830. This was done with much consternation, as the Native Americans considered their lands a gift from the Creator and held deep spiritual ties to the land. The original Indian Territory was much larger until Kansas and Nebraska were granted statehood in 1861 and 1867, respectively. (Archives and Manuscripts, Oklahoma Historical Society.)

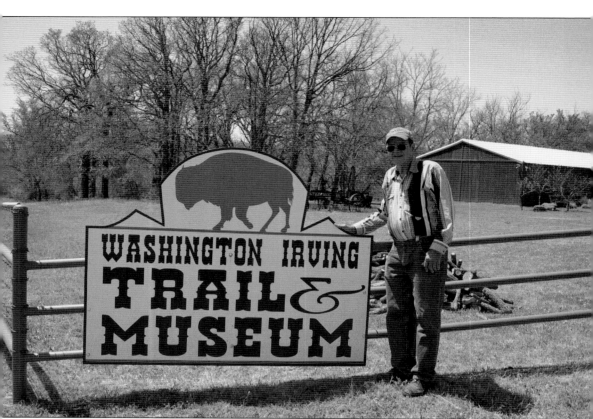

Dale Clouber is proud of Oklahoma, and especially of Payne County. So much so, in fact, that he has spent his retirement singlehandedly building the Washington Irving Trail Museum. Much history has taken place near here, a few miles east of Stillwater. The first Civil War battle in Indian Territory occurred a few miles north, near Yale, in 1861. Jim Thorpe, considered the world's greatest athlete of 20th century, grew up in Yale. In 1893, the famous battle between the Doolin-Dalton Gang and US Marshals took place in nearby Ingalls. In 1923, the world's first cowboy band, the Billy McGinty (then the Otto Gray) Band was the first to play over the radio. Clouber's land was actually homesteaded by the family of Otto Gray (of cowboy band fame). A few miles to the west, David Payne and his Boomers camped along Stillwater Creek in an effort to open the lands to white settlement. And of course, as the name of the museum implies, Washington Irving traveled through the area on his expedition to write about the American West. His book became a best seller and told the readers what life was like on the frontier. The museum has an extensive collection of rare and ancient artifacts, both from the area and from around the country. No trip to this region should exclude a visit to the Washington Irving Trail Museum. (Author's collection.)

Two

COWBOYS AND INDIANS
FROM FOES TO FRIENDS

The Civil War shaped the next several years of the area. Thousands of Indians joined US representatives in Fort Smith, Arkansas, on September 8, 1865, for a council working on the relationships that were severed by mutual distrust. Many Native Americans owned black slaves and thus sided with the Confederacy. Doing so, they unknowingly forfeited lands given in exchange for confiscated homelands in the Southeast 35 years earlier. After months of negotiations, treaties, and buyouts, the natives knew the time had come for life as they knew it to drastically change.

The efforts of two of the Fort Smith Council's most notable representatives, Milton Reynolds and Elias Boudinot, must be recognized.

Fascinated by early frontier life, Reynolds, an advocate for white settlement, wrote for his own *Kansas State Journal* and the *New York Times*, advocating harmonious existence of the new settlers and the natives.

Three decades prior, Boudinot's father was murdered for his participation in the New Echota Treaty, which traded Cherokee homelands in Georgia for lands in the territories. This prompted the young man's involvement as a Cherokee delegate in the council, where he formed close ties with Reynolds. Their mutual goal was to form a land where new settlers and natives would not only survive but would thrive as neighbors.

Years later, David Payne and William Couch took the reigns and started what became known as the Boomer movement. In 1884, they led a contingent of 200 on a trek 58 miles southward from their home base of Arkansas City, Kansas. They forged along Ponca and Otoe-Missouria tribe provision routes, with the final 30 miles through unbroken prairie, finding their ideal location along Stillwater Creek in the Unassigned Lands.

The Unassigned Lands consisted of two million acres for nomadic tribes roaming the plains, eventually being confiscated as a consequence of the Native Americans fighting for the South.

Becoming the activist leader of the Boomer movement after Payne's death, Couch led multiple expeditions to Stillwater Creek, attempting, unsuccessfully, to be arrested in hopes of drawing national attention to the movement to open these lands to settlement. Each attempt was met by US Marshals escorting the participants back to Kansas. They were seeking clarification from Congress on disparities between homesteaders, cattlemen, and natives. This area would become an island of white settlement surrounded by Indian lands. Finally, the Boomers' perseverance paid off. Congress was persuaded to open the lands.

The name *Stillwater* comes from the name of the nearby creek. Two theories have been discussed, with no proof of either. One is that the cattlemen and farmers were happy that there was still water in the creek every year, even in dry weather. The other theory states that Indians had noted its still (or quiet) water except during heavy rainfall. The official designation came in late 1884, when William L. Couch named both the creek and his Boomer colony Stillwater.

Lt. M.H. Day was one of several of the US Marshals that routinely escorted Captain Payne, William Couch, and their party from the Still Water Valley along Stillwater Creek (near present-day Couch Park). While the Boomer activists wanted to be arrested, thus drawing attention to these Unassigned Lands, they were taken back to the Kansas state line only to organize their next adventure back to the Still Water Valley. (OSU Library, Special Collections.)

OKLAHOMA

CAPT. PAYNE'S

OKLAHOMA COLONY

Will move to and settle the Public Lands in the Indian Territory before the first day of December, 1880. Arrangements have been made with Railroads for

LOW RATES.

14,000,000 acres of the finest Agricultural and Grazing Lands in the world open for

☞ FREE HOMES ☜

For the people—these are the last desirable public lands remaining for settlement.
Situated between the 34th and 38th degrees of latitude, at the foot of Washita Mountains, we have the finest climate in the world, an abundance of water, timber and stone. Springs gush from every hill. The grass is green the year round. No flies or mosquitoes.

The Best Stock Country on Earth.

The Government purchased these lands from the Indians in 1866. Hon. J. O. Broadhead, Judges Jno. M. Krum and J. W. Phillips were appointed a committee by the citizens of St. Louis, and their legal opinion asked regarding the right of settlement, and they, after a thorough research, report the lands subject under the existing laws to Homestead and Pre-emption settlement.

Some three thousand have already joined the colony and will soon move in a body to Oklahoma, taking with them Saw Mills, Printing Presses, and all things required to build up a prosperous community. Schools and churches will be at once established. The Colony has laid off a city on the North Fork of the Canadian River, which will be the Capital of the State. In less than twelve months the railroads that are now built to the Territory line will reach Oklahoma City. Other towns and cities will spring up, and there was never such an opportunity offered to enterprising men.

MINERALS!

Copper and Lead are known to exist in large quantities—the same vein that is worked at Joplin Mines runs through the Territory to the Washita Mountains, and it will be found to be the richest lead and copper district in the Union. The Washita Mountains are known to contain Gold and Silver. The Indians have brought in fine specimens to the Forts, but they have never allowed the white men to prospect them. Parties that have attempted it have never returned.

In the early spring a prospecting party will organize to go into these Mountains, and it is believed they will be found rich in GOLD AND SILVER, Lead and Copper.

The winters are short and never severe, and will not interfere with the operations of the Colony. Farm work commences here early in February, and it is best that we should get on the grounds as early as possible, as the winter can be spent in building, opening lands and preparing for spring.

For full information and circulars and the time of starting, rates, &c., address,

T. D. CRADDOCK,
General Manager,
Wichita, Kan.

GEO. M. JACKSON,
General Agent,
406 Chestnut St., St. Louis.

Throughout the 1800s, people could spot this poster all along the southern Kansas border, especially around Arkansas City and Winfield, the closest Kansas towns to the new colony. These posters, popular in the West to lure people to these previously unknown lands all across the frontier, were often filled with inflammatory and exaggerated claims. This one states that the area has the world's best stock and grazing lands, situated at the feet of the Wichita Mountains, with springs gushing from every hill. It also says the grass is green year-round and that there are no flies or mosquitoes! Land seekers were also promised vast areas for the discovery of lead, copper, gold, and silver. The real truth be known, though, it would be the undiscovered oil and natural gas that would change the face of the area. Future generations benefitted from the "black gold" and, more recently, natural gas hidden beneath their ancestors' claims. (Western History Collections, OU Library.)

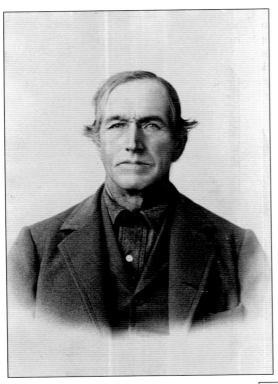

Meshach Couch and his wife, Mary Bryan Couch, along with their family—including their three sons, William Lewis, Meshach Quinton, and Joseph— had emigrated from the mountains of North Carolina to Wichita, Kansas. They supported their son's efforts to open the lands south of Kansas to white settlement. Although not much is written about the elder Couch, it was said that he was a powerful force in the Boomer movement. He accompanied son William on the 1884 expedition to Oklahoma. The Couches were also instrumental in helping establish their son in Wichita businesses. Having previously owned a grain elevator to which farmers brought their seasonal crops of wheat and other grains, William was also engaged in the livestock industry starting in 1879. After the land run of 1889, Meshach and Mary Couch settled near Oklahoma City, Oklahoma, where they lived out their lives. (Both, Edna Couch family.)

David Payne, while modest, became a living legend, known as the "Father of Oklahoma" for his efforts in opening the area to settlement for whites. A second cousin of Davy Crockett, he was larger than life and quickly raised over $100,000 (almost $2.5 million in today's dollars) for his efforts for Oklahoma Colony. He died in 1884 before he was able to see his dreams realized. Stillwater became the county seat of Payne County, which was named after him. (Kansas Historical Society.)

William Couch encountered the gregarious and enthusiastic David Payne, encouraging him to join his expedition to Oklahoma Colony. Cattle drives through the territory intrigued him. Sending his wife to live with his parents, he joined the group of adventurers and became Payne's right-hand man. (Edna Couch family.)

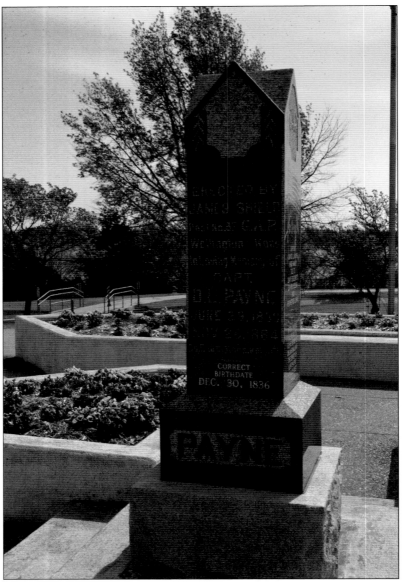

CORRECT
BIRTHDATE
DEC. 30, 1836

PAYNE

Several expeditions into the Oklahoma lands, each followed by US Marshals escorting them back to Kansas, made Couch and Payne heroes and generated more excitement than ever. That excitement faded on November 28, 1884, when Payne died while eating breakfast in Wellington, Kansas. After only 10 days, William Couch, who had become the vice president of the colony, quickly led another group and camped at the banks of Stillwater Creek, naming the new village Camp Stillwater. On Christmas Eve, 1884, a group of 39 soldiers arrived to force the Boomers off the land. They were outnumbered and sent for reinforcements. The fortification came soon, but it was during a brutal blizzard. Many soldiers became ill and were doctored by the Boomers. This may have placated the tensions of the two parties, but it angered General Sheridan. This, with many other incidents, contributed to the eventual success of opening the lands. After 110 years, Payne's body was moved from Wellington, Kansas, to its rightful home at Boomer Park in Stillwater. (Author's collection.)

Elias C. Boudinot was a central figure in the eventual opening of lands to white settlement. His father, murdered in 1839 for signing the 1835 New Echota Treaty, which traded Native American homelands for lands in the Indian Territory, inspired him to devote his life to his people. He thought that the survival and future of his Cherokee heritage would depend upon working with whites. He penned his thoughts about moving: "Removal is the only remedy, the only practicable remedy." Like his father, his stance would cause disunity among fellow Cherokees. Ironically, he shared his father's fate. He was ambushed and murdered with knives and tomahawks at his Park Hill, Indian Territory, home near present day Tahlequah, Oklahoma (capital of the Cherokee Nation). (Archives and Manuscripts, Oklahoma Historical Society.)

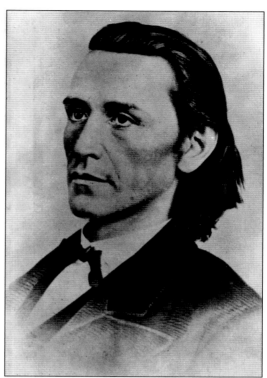

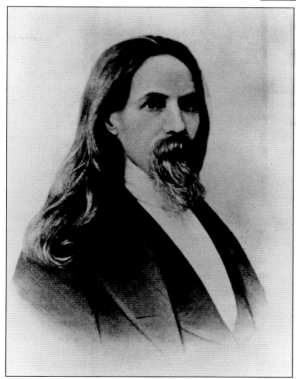

Daniel N. McIntosh, known as "Dode," a Creek, became an activist. He was incited after his father was murdered for signing the Creek Removal Act. He commanded a Creek Indian regiment for the Confederacy during the Civil War. McIntosh then led the Creek delegation to the Fort Smith Council in 1865, followed by a trip to Washington to represent the Creeks in negotiations concerning the Treaties of 1866. (Archives and Manuscripts, Oklahoma Historical Society.)

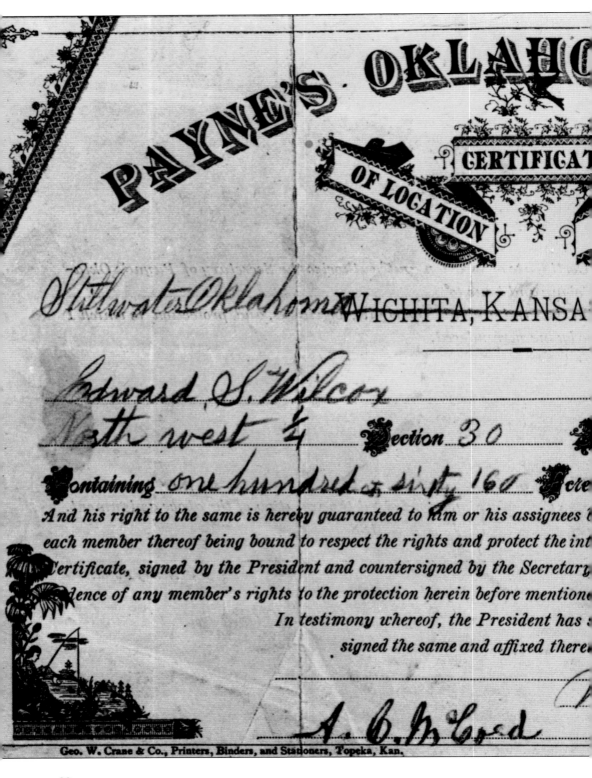

PAYNE'S · OKLAHO[MA]

CERTIFICAT[E]
OF LOCATION

Stillwater Oklahoma WICHITA, KANSA[S]

Edward S. Wilcox

North west ¼ Section 30

Containing *one hundred + sixty 160* [A]cre[s]

And his right to the same is hereby guaranteed to him or his assignees [?]
each member thereof being bound to respect the rights and protect the int[erest]
[C]ertificate, signed by the President and countersigned by the Secretary,
[evi]dence of any member's rights to the protection herein before mentione[d]

In testimony whereof, the President has [?]
signed the same and affixed there[?]

A. C. McCord

Geo. W. Crane & Co., Printers, Binders, and Stationers, Topeka, Kan.

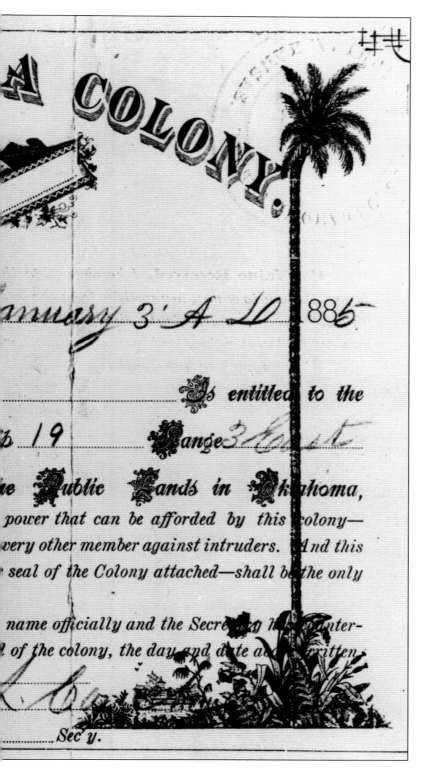

A COLONY.

January 3' A D 1885

Is entitled to the

19 Range 3

the Public Lands in Oklahoma,
power that can be afforded by this colony—
every other member against intruders. And this
seal of the Colony attached—shall be the only

name officially and the Secretary the counter-
of the colony, the day and date as written.

Sec'y.

Edward S. Wilcox received this certificate on January 3, 1885, after taking possession of his 160 acres in what was known as Payne's Oklahoma Colony. Since most of the men of the Boomer colony hailed from Kansas, approximately 60 miles to the north, these ownership certificates were patterned after the certificates used in their home state. Notice "Wichita, Kansas," scratched out and replaced by the new name of the area formerly known as the Still Water Valley—Stillwater, Oklahoma—despite the fact that statehood would not come for another 22 years.

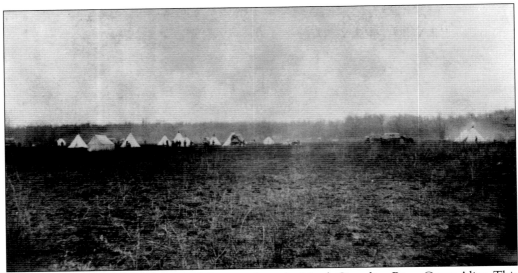

Payne, Couch, and their party named this site along the North Canadian River Camp Alice. This was considered their most perilous expedition, and they were arrested in 1883, practically dragged to the Texas border, and then taken to Fort Smith for their trial. This was one of the more notorious trials that began to gain traction for the Boomer movement. (Kansas State Historical Society.)

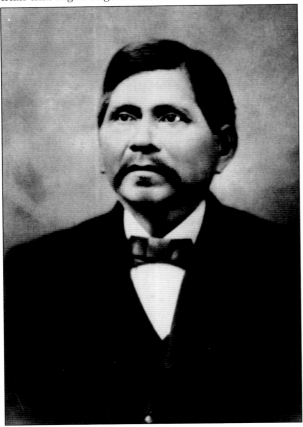

Although Rev. Allen Wright is not a very well-known figure, his contribution cannot be denied. In 1866, the Indian Territory became two territories after the Indians ceded lands to the government. Wanting a new name for the newest territory, Wright, an educated Choctaw minister, proclaimed "Oklahoma," a combination of two Choctaw words, *okla*, meaning "home," and *homma*, meaning "red." *Oklahoma*, therefore, translates into "land of the red people." (Archives and Manuscripts, Oklahoma Historical Society.)

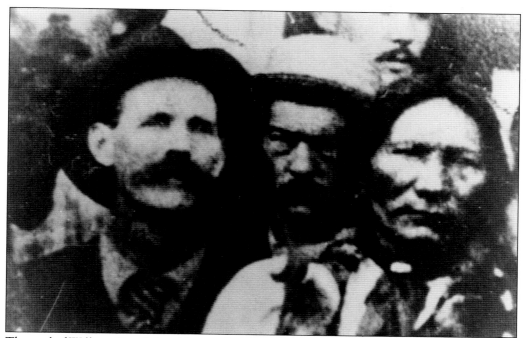

The goal of William Couch is evident in this photograph of him with Bull Bear of the Cheyenne Tribe. He wanted the area to be opened to white settlement but also advocated for the harmonious existence with the Native Americans already living in the area. (Edna Couch.)

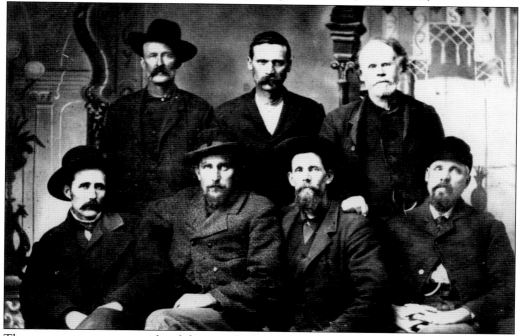

These seven men were considered the main leaders of the Boomer movement. Seated in the front are, from left to right, A.C. McCord, David Payne, William Couch, and a man known as "Pugsley." Standing are, from left to right, H.H. Stafford, Mr. Goodrich, and Alfred P. Lewis.

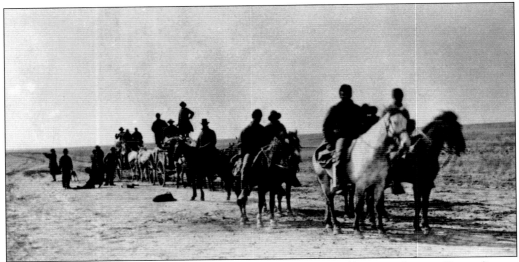

David L. Payne died on November 27, 1884. Pictured on one of last expeditions, Payne (in top hat, at center) leads a group of Boomers across the Kansas state line in 1883. This, along with many other treks into the territory, was instrumental in the eventual opening of the territory to non-Indian settlement. (Archives and Manuscripts, Oklahoma Historical Society.)

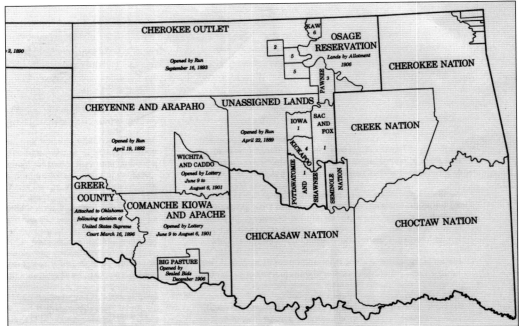

This map shows the various areas and means of opening the lands to settlement. While the Unassigned Lands, the Cherokee Outlet, and Indian lands of Cheyenne, Arapahoe, Sac and Fox, Iowa, Kickapoo, Shawnee, and Pottawatomie were all opened by land runs, other areas were opened by lottery, allotment, and sealed bids. The author's great-grandfather, Horace Wesley Jones, made the 1892 land run into Cheyenne and Arapahoe Territory near present-day Thomas but left after a few months, complaining there were "too many Germans." The family would return from Texas and settle near Sweetwater, Oklahoma. (Oklahoma Historical Atlas.)

Three

HARRISON'S HORSERACE
THE GREAT LAND RUN OF 1889

After negotiations with the Creek and Seminole tribes, and the payment of approximately $2 million to each tribe, the way was paved for Pres. Benjamin Harrison to sign the proclamation on March 23, 1889, opening the Oklahoma Territories' Unassigned Lands to settlement on April 22, 1889.

In Arkansas City, Kansas, thousands of excited and hopeful men, women, and children from all walks of life gathered to stake a claim in the fabled Indian Lands.

Robert Lowry discovered a major discrepancy: unlike the three other borders, land-seekers from the north had to travel almost 60 miles south to reach the starting line (which runs through present-day Stillwater). This would be a distinct disadvantage. Lowry's connections as an attorney got Washington's attention, and the problem was solved.

They agreed the Boomer site along Stillwater Creek, promoted by Couch and Payne, would be ideal. Thus began the journey of thousands from the southern Kansas border to the new starting line, 58 miles south.

Crossing a rain-swollen Salt Fork Creek, wagons washed away, horses drowned, and people needed rescue. When a group of Indians (probably Ponca or Otoe-Missouria) saw the trouble, they strung a cable across the flooded creek to aid the homesteaders. Although they charged $2.50 per family, they bravely risked their lives to save the settlers, and no lives were lost.

The following afternoon, as the caravan of homesteaders crested the hill, the clouds parted, the sun shone, and tears flowed as thousands got their first look at their new home. Green pastures with full creeks were lined with elm, sycamore, and pecan trees. Native redbuds were likely in full bloom, welcoming the settlers to the Valley of Still Water.

Finally, the day of great anticipation arrived. Over 100,000 people from across the world crammed the area's four borders. The federal government divided the two million acres into 11,000 parcels of 160 acres each. More than 20,000 people made the trip on 20 cramped trains. They unloaded at Oklahoma Station and Guthrie, with each gaining roughly 10,000 eager settlers. Without the advantage of trains, Stillwater gained only a handful, including some who jumped the line before the noon starting time, illegally staking their claim. These so-called "sooners" become the valley's newest residents. Today, the label "Sooner" is still considered by many a disparaging term, as it is the name of the University of Oklahoma's athletic teams. To keep their claims, homesteaders would be required to build a permanent residence and cultivate the land for five years.

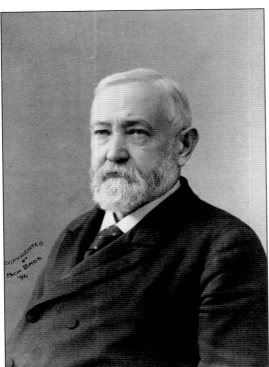

On March 23, 1889, Pres. Benjamin Harrison signed into law the proclamation that would open the Oklahoma lands for settlement at 12 noon on April 22, 1889. This would be made possible by means of a great land run, dubbed "Harrison's Horserace," whereby home seekers would be entitled to rush to their 160-acre claims. This would enable Stillwater to become the first town in the territory. (Library of Congress.)

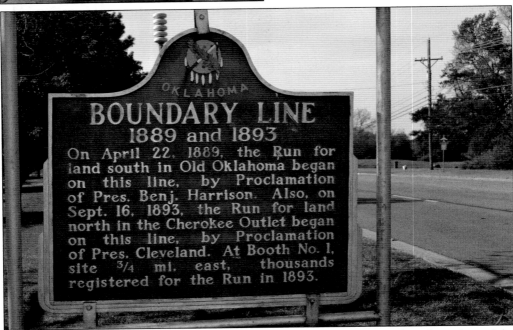

This marker, in north Stillwater, shows the exact east-west line of the northern boundary of the Unassigned Lands. Thousands eagerly lined up along this border in 1889 for the land run, seeking new homes to the south. On September 22, 1893, the same line was the southern boundary for the land run to the north, opening the Cherokee Outlet.

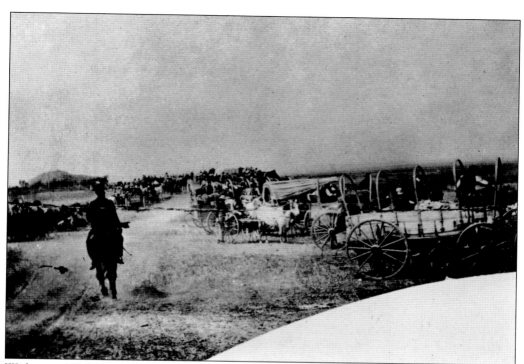

With over 100,000 eager settlers all lined up around the borders of the lands to be opened, lawmen and cavalrymen helped keep the peace. They were also trying to keep the sooners from jumping the line too early. (OSU Library, Special Collections.)

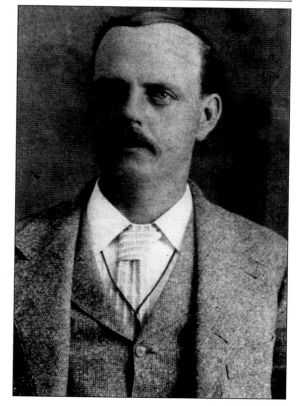

Known as the "Father of Stillwater," Robert Lowry was a true pioneer and earned his title. From Illinois, then Iowa, he was one of the first to participate in the land run and claim his 160 acres; he immediately donated 80 acres of it for a townsite. He went on to plan the town's layout, become the first postmaster and town councilman, and lead the fights for Stillwater to become the county seat and land the soon-to-be-approved land-grant college. (*Stillwater News Press.*)

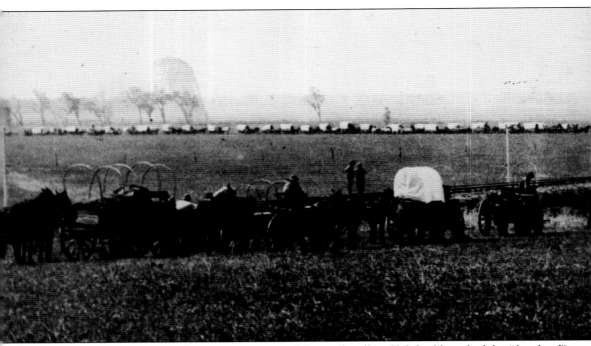

For years, people from all across America and from all walks of life had heard of the "free land" being given to those who wanted it. Finally, the time had come, and 4,000 eager souls seeking a new life in the Unassigned Lands were crossing from Kansas through the Cherokee Outlet, a distance of 58 miles. Robert Lowry may have been a lawyer, but he had a way of describing the scenes of the day. He wrote, "The winding cattle trails to the territory being opened were

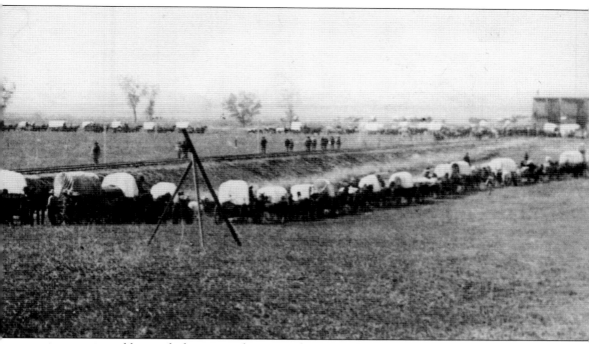

moving, waving ribbons of white-topped prairie schooners, flanked and followed by troops of horsemen." As they crossed the Kansas line, hundreds of excited citizens stood by and cheered on the caravan, many with signs saying "On to Oklahoma" or "Oklahoma or Bust." (Western History Collection, OU Library.)

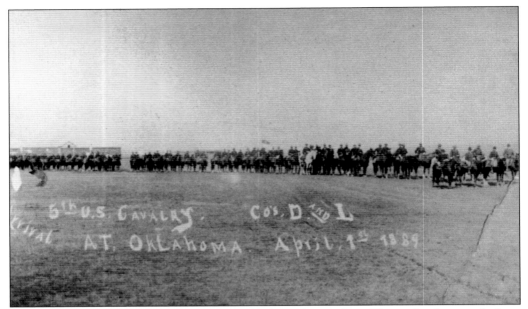

5th U.S. Cavalry. Co's. D 2nd L AT. OKLAHOMA. April 1st 1889

Camps of settlers seeking new homes were all along the southern Kansas border, mostly from Arkansas City to Caldwell. The 5th US Cavalry was sent to keep order. It also escorted the settlers south to the northern border of the Unassigned Lands and stayed to supervise the land run on April 22, 1889. (Archives and Manuscripts, Oklahoma Historical Society.)

Leading up to the land run, there were several attempts at settling the territory, albeit against the law. It was their way of drawing attention to the cause. Here, the Boomers have set up camp near present-day Couch Park in Stillwater. (Archives and Manuscripts, Oklahoma Historical Society.)

Louis J. Jardot, originally from France, homesteaded 160 acres at what are now Twelfth Avenue and Western Road. On his way to the starting line, he was approached by Indians, probably from the Otoe-Missouria tribe, near present-day Red Rock. Scared, he kept his composure as the Indians led him over the hill. Not knowing what was going to happen, he was relieved that more Indians were there to give him food and wish him well on his journey. The next day, he arrived at the new starting line, ready to stake his claim.

After heavy rains, the home seekers that were heading south to the land run border were struggling to ford the rain-swollen Salt Fork Creek. They were about to give up when Indians come to the rescue, aiding them with cables and seeing that no lives were lost. (Author's collection.)

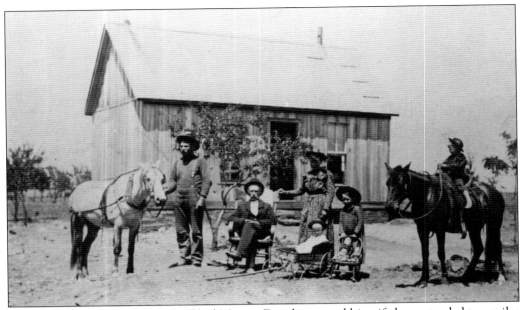

One of Stillwater's first lawyers, Alfred Marion Dougherty, and his wife homesteaded two miles south of Ingalls during the 1889 land run. Although he built his cabin on the homestead, Dougherty spent most of his time engaged with his law practice out of his Stillwater Hotel office. The below photograph is of Alfred's son Royal Dougherty posing with his wife, Sadie, years after he had lived there as a boy. The above photograph was taken in 1900 of the Dougherty family. Alfred is seated in the chair, flanked by his son Royal (next to his horse), and Royal's wife. The children are Arthur (in the baby carriage), Dale (standing beside Arthur), and John (on horse). The family was friends with the infamous Doolin and Dalton boys. The day of the famous Ingalls gun battle, the members of the gang borrowed a horse from Alfred. Alfred died in Stillwater while in court in 1902. (Both, author's collection.)

Four

THE BIRTH OF A TOWN
TURNIPS AND TENACITY

While the Valley of Still Water became known around the world for the controversy surrounding the Boomer movement, it offered very little as a new townsite. With no railroads, no roads or bridges, and no cattle trails, it was difficult to recommend the area to settlers wanting a new life in the territory. The first year certainly didn't help, as a severe drought plagued the area. As only turnips would grow, it became known as "the Year of the Turnip."

Stillwater citizens owe a great deal of thanks to the community's earliest pioneers. These were very young men, most in their 20s and 30s. They had the foresight to know there would be many difficult decisions and fights ahead of them.

First would be the location of the townsite. They formed the Stillwater Town Company and sold 119 shares of stock. With no precedent from which to model, the organizers incorporated under Nebraska law, citing the May 3, 1890, act of Congress that made certain laws of Nebraska applicable to Oklahoma Territory. The company charged a committee with the planning and development of the town where Stillwater Creek empties into the Cimarron River (11 miles southwest of present-day Stillwater), but some had other ideas. They scouted Cow Creek, Boomer Creek, and the original Boomer camp along Stillwater Creek as more suitable locations for the new town. While deciding their next move, Lewis Cooper, a Stillwater Town Company shareholder, discovered an unclaimed 80-acre parcel of land right in the middle of the area. Their prayers were answered.

There was, though, a legal fight, due in part to a man named Garnett Burks. He was picked by the Stillwater Town Company to claim the acreage and deed it back to the town. Seeing this as an opportunity to add 80 acres to his own claim, he seized the moment and began working toward keeping it for himself. After much discussion and pressure from residents, cooler heads prevailed. The matter was eventually settled, and the town was free to proceed and locate at its present site.

The first citizens of Stillwater had to deal with life without a railroad. Virtually every prospering town was on a railroad line. Supplies, ranging from wood, brick, hardware, and other building materials, as well as home goods, mail, and food, all had to be brought in by wagon over rough trails from Orlando, Oklahoma, 35 miles west. Of course, people themselves were not immune to the rough five-and-a-half-hour ride. This was not only a hardship for residents, shopkeepers, and builders; it was also a roadblock for people considering Stillwater as their next home.

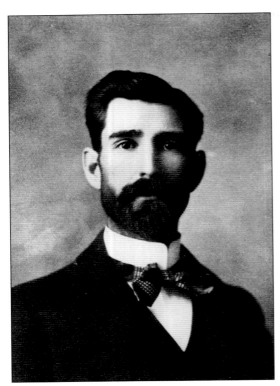

Frank J. Wikoff accomplished much by the age of 24. In August 1889, he became the first city attorney, and he wrote Stillwater's original charter. He then headed the group that brought Oklahoma A&M to town. He became president of Bank of Commerce, later moving to Oklahoma City to become president of the larger Tradesmen National Bank before becoming territorial bank examiner. He moved to California and lived out the rest of his life there.

Garnett Burks was an original member of the Stillwater Townsite Company. When the company found a great spot for the townsite, it asked Burks to quickly claim it for Stillwater. He had other ideas and, after claiming it, tried to keep it for himself. Through legal action and alienating harassment, he was forced to relent, and the land that is now downtown was finally in the right hands.

Just after the land run, 24-year-old Henry Brown Bullen built Stillwater's first lumber and coal yard on South Main Street. To keep their homesteads, new residents had to build on their property, and they bought supplies from Bullen's store. He was part of the first townsite company and was instrumental in establishing the school system. The below late-1890s photograph shows the Bullen family, Henry and Carrie with son Clarence, and friend Florence Felt in the fancy "surrey with the fringe on top," to quote a famous line from the state song, "Oklahoma!"

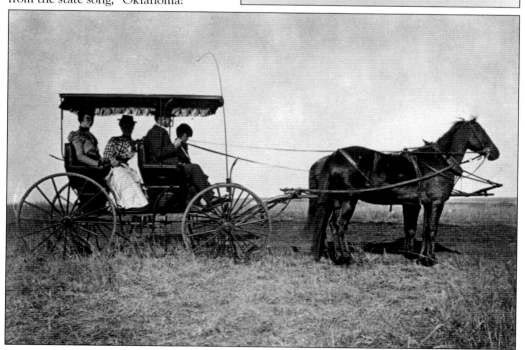

Natives of Ohio, Simon Peter Duck and wife Sarah Jane homesteaded on land a mile west of the townsite. Before his trek to Oklahoma, Simon fought in the Civil War at Vicksburg and Pea Ridge. They, along with their nine children, became prominent citizens, with Duck Street as their namesake.

Born in Germany in 1873, Jacob (Jake) Katz came to Stillwater in 1894. In 1896, he opened Katz Department Store, which was in business for over 100 years before closing. After a couple of moves and name changes, it found its permanent home at 707 South Main Street.

William J. Hodges was the first president of the Stillwater Townsite Company. He thought that position would be enough to secure the townsite on his land, three miles west. Other town leaders had different ideas, and he lost to the present site. (*Stillwater News Press.*)

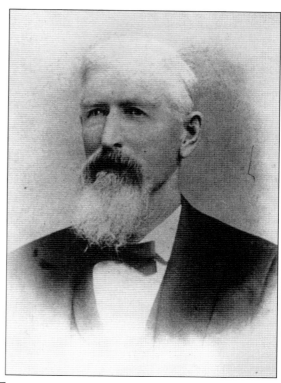

Stillwater's first business directory lists 156 businesses, including lumberyards, sawmills, blacksmith shops, many lawyers, doctors, pharmacists, shops, and even two stagecoach lines. Most early-day prominent residents are listed in this one-page directory. (Clarence Bassler Heritage Collection, Stillwater Public Library.)

Stillwater's location may have been the dream of the original boomers, but it was a tough sell for many. Its isolation was a problem. To take care of the citizens, Dr. James Buchanan Murphy came to the remote town and became its first doctor and pharmacist. He was mayor for only two weeks and was a charter member of the Masonic Lodge, Elks, Odd Fellows, and Woodmen of America. He died in 1924.

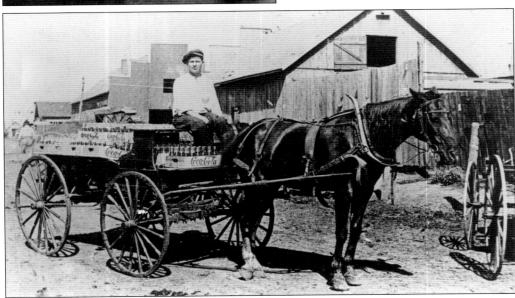

Stillwater may have been far from other larger cities, but Fred Knowles made sure the citizens "enjoy[ed] the real thing" and brought Coca-Cola along the rough five-and-half-hour ride from Orlando, Oklahoma, 35 miles west.

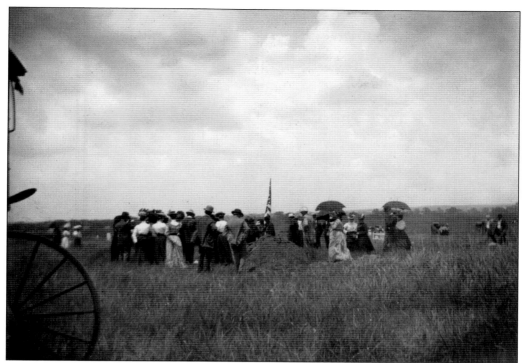

Cemeteries obviously would not have been established upon the arrival of the new settlers. The pioneers did what they had to do, often burying their dead out in the open prairie. The vehicle in the foreground was possibly used as a hearse.

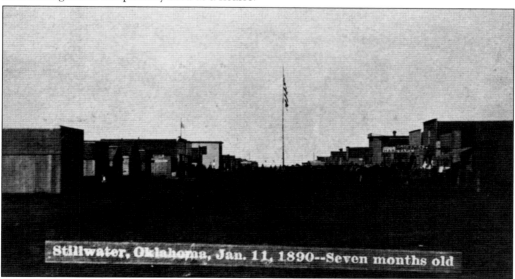

Stillwater, Oklahoma, Jan. 11, 1890--Seven months old

Stillwater was only seven months old, but the town was taking shape. Taken on January 11, 1890, this image is the first known photograph of Main Street. The remote location of Stillwater required a "beacon" for visitors to see. This 84-foot-tall flagpole was built of four long cedar posts, end on end. A flag measuring 25 feet by 18 feet was made by local women using 75 yards of bunting. The pole was top lit by a kerosene lantern, allowing it to be seen for miles at night. (OSU Library.)

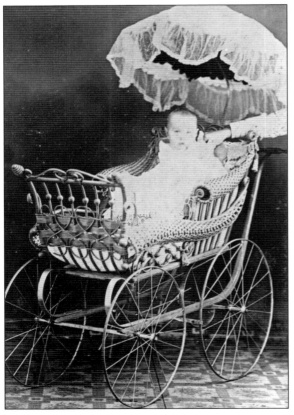

Joshua Brock (center) and his coworkers were the builders of the Citizens Bank building on East Ninth Avenue in 1894. Now the oldest commercial building still standing, it has housed several businesses and remains in use today.

Two-month-old Dorcas Blouin posed for this photograph in 1899. Her father, James Blouin, financed the construction of the opera house. As an adult, Dorcas became Payne County deputy court clerk.

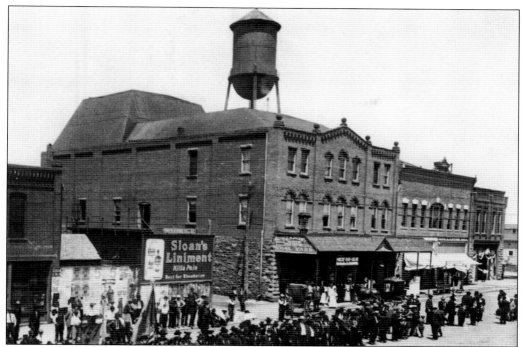

In 1900, Stillwater was a small town of approximately 450. That did not stop Louis J. Jardot from erecting the opera house at 116 East Ninth Avenue. Jardot constructed the building with bricks from his brick plant, while James Blouin financed the venture and operated a furniture store on the first floor. The venerable Remy and Shepherd Furniture was housed here until the 1980s.

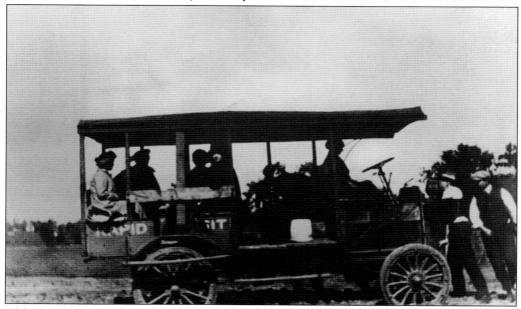

Although the streets were dirt and often muddy, there was a way for citizens to get around without having to jump on their horses. As labeled, this was the first rapid transit. It may not have been too "rapid," but it was a way to get across town.

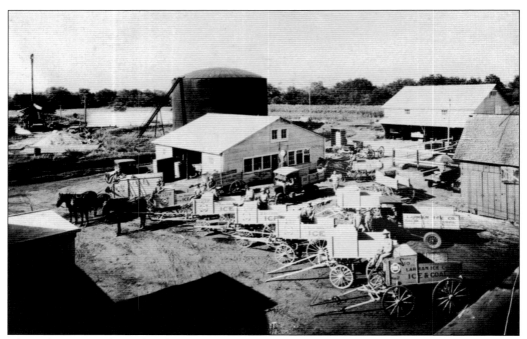

The Lahman Ice Plant played an important role in early daily life in the frontier. Without the luxury of refrigeration, women could not keep their milk, fruits, and vegetables fresh. Refrigeration enabled them to buy the produce and milk from shops to use anytime at home. Stillwater was also served by Simanks Ice Plant and Southwest Ice Company.

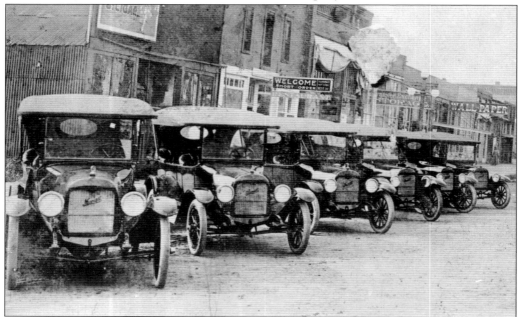

In 1916, Herbert Ricker decided to join the "new-fangled" automobile business and open the Maxwell Agency in the 900 block of South Main Street. Maxwell automobiles were shipped on trains, without wheels and standing on end. Ricker had to assemble them at the shop.

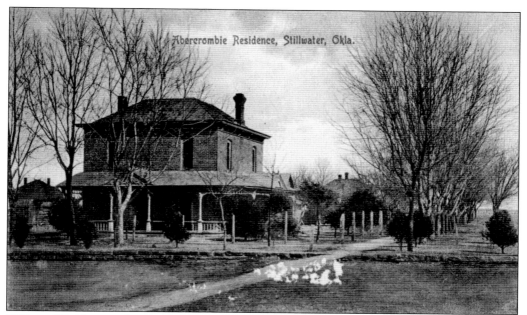

Abercrombie Residence, Stillwater, Okla.

William W. Abercrombie, a man of many talents, served as Stillwater's mayor from 1902 to 1903. He and his son-in-law Peter Miller opened Stillwater's first meat market, below. They also began selling produce after homeowners were able to obtain ice from the new ice plant. Additionally, the two men also opened and operated Stillwater's first cotton gin and the first power plant, built on Boomer Creek, just north of the feed mill. This served the small town until the new one was constructed north of town at Boomer Lake, its current location. The above photograph is of the 1890 Abercrombie home at 623 South Lewis Street. One of the oldest homes still standing, it currently houses a title company. (Both, author's collection.)

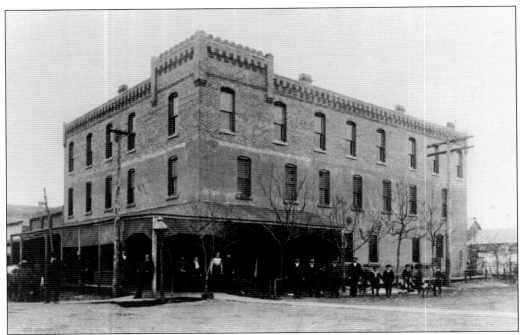

Behind the first street-lighting system of downtown sits the Youst Hotel. Built in 1894, it sat elegantly at the northwest corner of Eighth Avenue and Main Street. Many late-1800s buildings included an awning to keep visitors protected from the elements. This was the family that first built Yost Lake (the spelling was later changed by the post office).

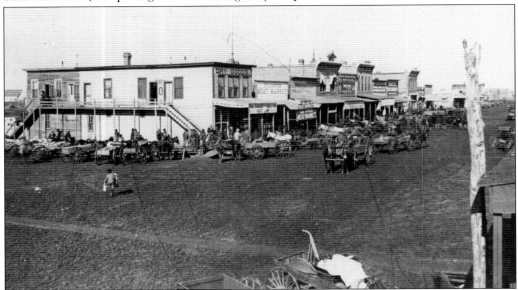

Amon W. Swope built this rather nondescript frame building at the corner of Ninth Avenue and Main Street. What it lacks in looks, it makes up for in history. Swope, along with T.W. Myton, started Stillwater's first bank, Stillwater National Bank. They also organized the Methodist Episcopal church. Church services and the first school classes were held on the second floor. This was also the site of the first city hall.

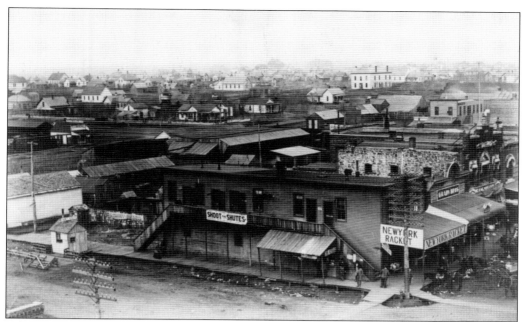

Taking over the Swope Building, the New York Racket Store dominates the corner of Ninth Avenue and Main Street. It was described by the owner's daughter as "a typical old time general merchandising store that carried everything except groceries." In the background sits the white-framed, two-story second courthouse.

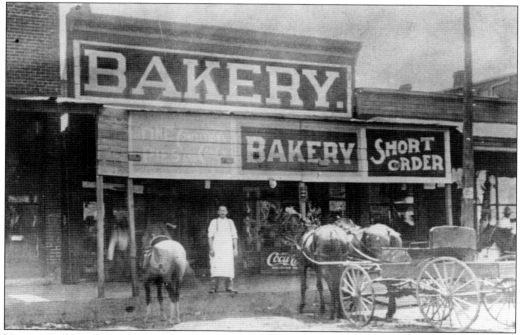

Hungry Stillwater citizens rode up on horseback to satisfy their cravings for pastries from Stillwater's first bakery on the east side of the 900 block of South Main Street. The sign at the right indicates that this may have become a lunch place with short-order meals.

Payne County Bank and Farmer's and Merchant's Bank consolidated, forming First National Bank, shown here in 1900. Built on the southwest corner of Eighth Avenue and Main Street, the second floor housed the early dental office of Dr. E.L. Moore.

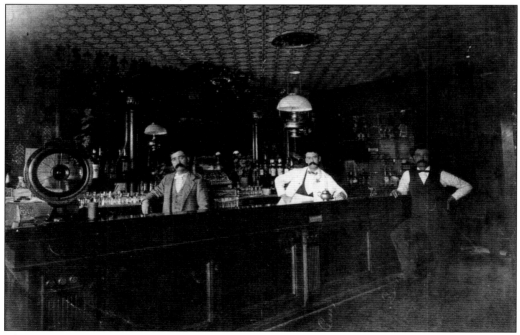

The new town brought people from all walks of life. Along with the many teetotalers, there were plenty that needed a stiff drink after a long day. Before Prohibition came with statehood in 1907, there were plenty of saloons to satisfy the thirst of those who fancied liquor. Pictured here at the Long Branch Saloon are, from left to right, Sam Myers, Jerry Small, and Sam Nicely.

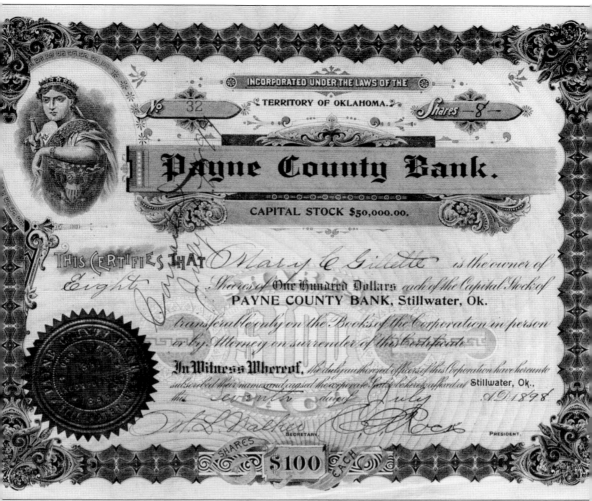

Mary C. Gillette bought eight shares of $100 stock in the new Payne County Bank. She was the 32nd to buy stock toward the banks' goal of raising $50,000. This was certified on July 7, 1898, and signed by Pres. C.A. Rock and secretary Walker. Many banks would follow, and it was noted that they were highly capitalized for such a new and remote town. In today's dollars, the bank stock would total $1.4 million, with each stock valued at about $2,800. (Dale Clouber.)

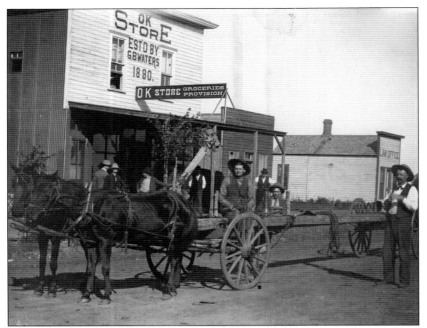

G.B. Waters built his OK Store in the middle of the 700 block of South Main Street. In front of the store, Peter D. Curtis (left) and John Kerby are seen with the trailer wagon used to move the famous OK Hotel from Ingalls to Stillwater in 1902.

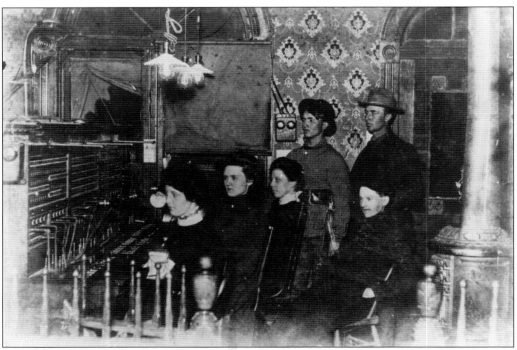

Communication has changed dramatically over the years. Stillwater was thrilled to join other cities in obtaining its first telephone and telegraph service in 1899. Pioneer Telephone and Telegraph served the area for many years. It started at 814 1/2 South Main Street, over Fred Stallard's saloon, before moving to 724 South Main Street, 702 South Main Street, and finally 502 South Main Street.

Ingalls, Oklahoma Territory, was a small town, known mostly for its saloons and lack of law. Incorporated in 1889, with its post office closing in 1907, it became famous as the site of the "Battle of Ingalls," in which US Marshals fought the Doolin-Dalton Gang and five lives were lost. This is a replica of the hotel moved to Stillwater in 1902. (Author's collection.)

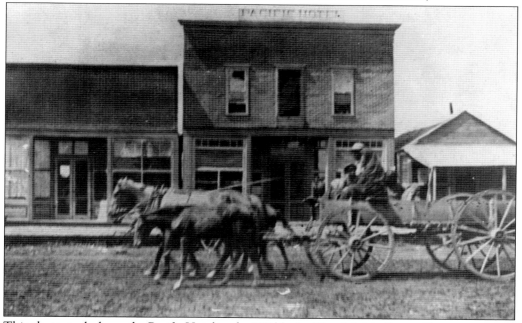

This photograph shows the Pacific Hotel in the 900 block of South Main Street. Construction was big business after the land run in 1889, and this hotel became the headquarters for the teamsters that came to town to build the many homes and businesses needed for the new community.

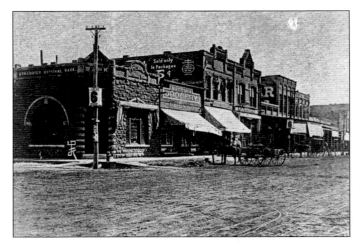

Built of native red and white sandstone, Stillwater State Bank (later Stillwater National Bank) sat on the corner of Eighth Avenue and Main Street, described by the *Payne County Journal* as "the best corner in town." The paper also stated that it was "ornamented and designed in a most beautiful manner." Shelly W. Kaiser, from Illinois, founded the bank and later sold his interest to the Berry family, who controlled it for many years.

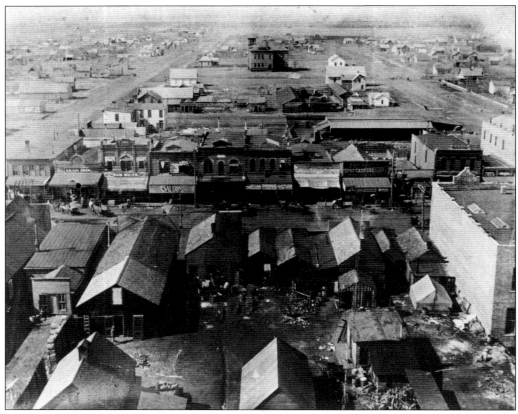

This 1899 photograph shows how Stillwater changed in its first 10 years. Along Main Street lie Amon Swope's building, Grady's Jewelry Store, and Sam Miller's Department Store, the first in Stillwater. In the far background sits Alcott School at Duck Street and Eighth Avenue. The First Baptist Church occupies the small white building to the left of the school. Directly opposite, across Eighth Avenue, sits the town's first Methodist church building.

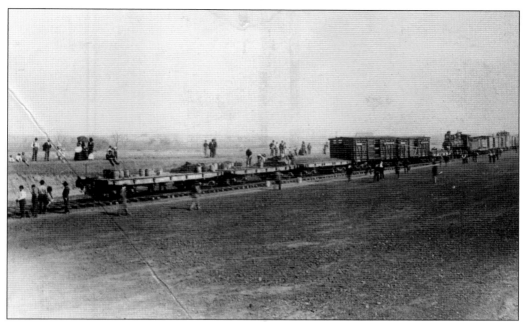

Stillwater had been isolated by its lack of roads and bridges. The rough five-and-a-half-hour trail to Orlando, 35 miles east, or the trail to Wharton, now known as Perry, were the only ways to get goods and building materials or even for people to travel to town. Overwhelming excitement filled the air as the railroad finally arrived in Stillwater. Eastern Oklahoma Railway completed the tracks to town on March 25, 1900. At 9:00 a.m., the whistled sounded to let residents know that their long wait was over. Over 700 people went to the station to welcome the first train. The tracks finally connected the towns of Ripley and Pawnee by way of Stillwater, and life would never be the same. The above photograph shows the construction train on its way to Stillwater. The image below, dating to about 1917, depicts citizens wishing Godspeed to the boys going to World War I.

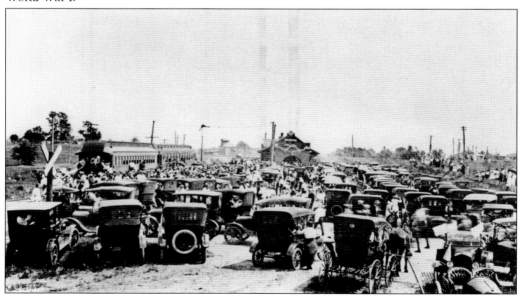

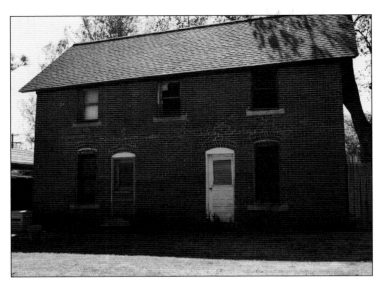

Chester Gould, originally from Pawnee and creator of the Dick Tracy comic strip, lived in this house when his family moved to Stillwater, where his father, Gilbert, published a local newspaper. Chester attended Oklahoma Agricultural & Mechanical College from 1919 through 1921. He drew the Dick Tracy comic strip from 1932 until 1977. He died in 1985 at age 89. (Author's collection.)

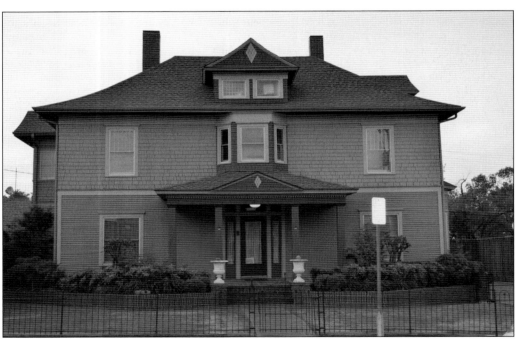

J.H. Connell, president of OAMC, built this beautiful home in 1908. Connell's sons resided there and began Beta Theta Pi fraternity. The house at 516 West Elm was sold to Leslie Swim and his father, Elmer, in 1917. They used their savings from working at Katz Department Store for a down payment on the $4,500 house. Leslie married Gert, raising several children in the home. It is now the world headquarters for Eskimo Joe's, "Stillwater's Jumpin' Little Juke Joint." Owner Stan Clark took great pride in restoring the home to its original grandeur. (Author's collection.)

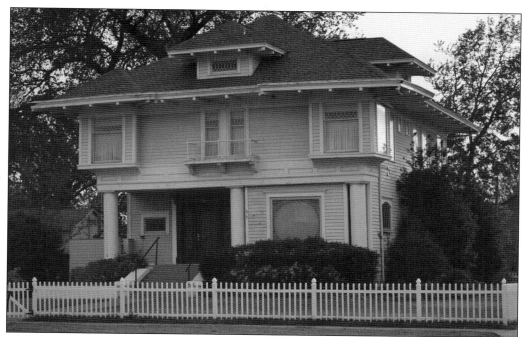

Although known as the Berry House, this home had two previous owners. It was built in 1910 by banker Marshall Edwards. In 1914, Dr. Whittenberg, who opened Stillwater's first hospital, bought the house, and he lived there until 1927. James Berry entertained many famous Oklahomans during his five terms as lieutenant governor of Oklahoma. It has also been the home of Sigma Nu fraternity and Alpha Delta Pi sorority. The home was placed in the National Register of Historic Places in 1980. (Author's collection.)

William Frick and his wife, Kathleen, came to Stillwater from their home state of Pennsylvania. They opened a feed store to serve the needs of area farmers. In 1903, they built this Folk Victorian home at 1016 South West Street, in Stillwater's most affluent neighborhood. Placed in the National Register of Historic Places in 1980, it looks much the same today.

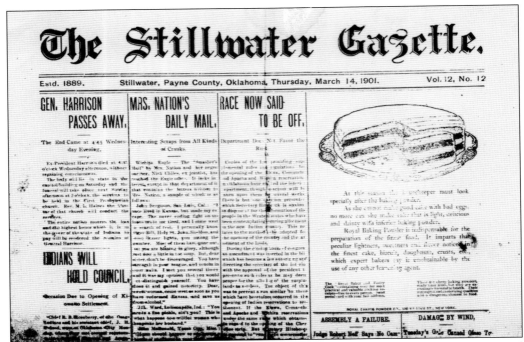

The early years brought with them many newspapers, as these were the sole source of news and information. Over 15 newspapers came and went during Stillwater's early days, including the *Standard*, the *Hawk*, and the *Gazette*. Dan Murphy started the *Gazette* in December 1889, and it was Stillwater's second newspaper. The above photograph of the *Gazette* is dated March 14, 1901. The article at left tells of the passing of former president and general Benjamin Harrison. He was the president that signed the proclamation opening the lands, thus allowing Stillwater to come into existence. The article below is news of another Indian conference opening more Indian lands to settlement, showing that much more work was to be done in the territories. The below photograph is of the *Gazette* staff. In the lower left is editor Northrup with Sue Edwards by his side. In the second row, from left to right, stand W.W. Davis, publisher Charley Becker, and Becker's son C.M. Becker.

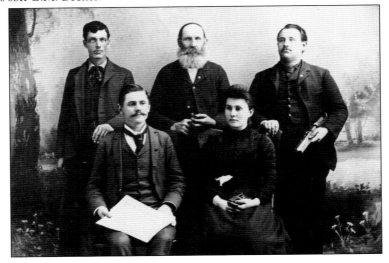

Five

FIGHTING FOR SURVIVAL
OUTSMARTING THE OTHERS

Stillwater was slowly growing, despite its lack of amenities. Other towns of "land-run beginnings"—such as Guthrie, Oklahoma City, Norman, and later, Perry—all had the distinct advantage of train service, roads, and bridges, which brought more manpower and supplies. Little did the early settlers know that two upcoming fights would be their source of survival. In one conflict, Perkins and Payne Center both vied to become the county seat. Perkins sent a contingent to Stillwater, but they were turned back before they crossed the creek, avoiding an armed altercation. Payne Center (three miles south of present-day Stillwater) built a courthouse and town hall to lure the county seat. Stillwater upped the ante, sending attorney Frank Hutto to Washington. Hutto convinced Congress to transfer five townships from the Cherokee Outlet to Payne County. The addition of Rose, Walnut, Eden, Glencoe, and Rock Townships would place Stillwater in the geographic center, the common and logical location Congress approved for county seats. On May 2, 1890, Congress officially designated Stillwater as the new county seat.

The next fight was for the land-grant college site. The Morrill Act of 1862 established agricultural and mechanical colleges, and the signing the Organic Act, establishing Oklahoma Territory, gave Stillwater's 600 residents more choices. Some wanted the just-announced penitentiary, others an insane asylum, and still others the normal school for teaching educators. There was even talk of luring the state capital from Guthrie. After talks, the community of Kingfisher agreed to seek the state penitentiary, backing Stillwater for the college.

But El Reno was also eager to get the college. Knowing that El Reno's delegate had an issue with whiskey, Stillwater delegates sent young cowboy Frank Ellis from the Z-V Ranch with $10 to assure the delegate would be too drunk to make the debate and vote in Guthrie. Stillwater won the vote, but the awarding of the land-grant college came with stipulations: raise $10,000 and provide land. Oklahoma City and El Reno hoped that Stillwater would fail. With the money raised and the land donated by several town leaders, the legislature declared Stillwater the new home for Oklahoma Territory Agriculture & Mechanical College on December 24, 1890.

After his work helping to establish Stillwater as a viable place to live, Robert Lowry settled in and practiced law for the next several years at his office on Eighth Avenue and Main Street. He never shied away from helping the fledgling town stay on course to become a true city. This photograph was taken in 1918.

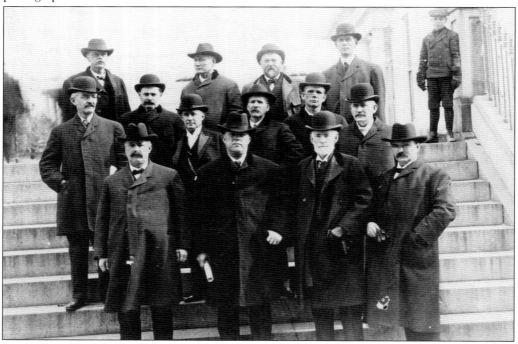

Robert Lowry, while known by many as the "Father of Stillwater," was also active in Oklahoma Territory matters. Here, Lowry (top left) poses with the delegation concerning statehood for the Oklahoma and Indian Territories.

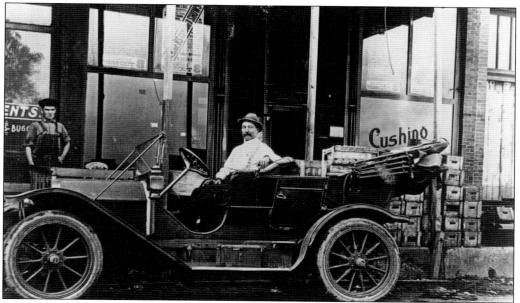

George Franklin Knowles and his wife, Maude, who made the land run of 1889, opened their meat market on Main Street. He became first local grocer to expand. With the success of the Cushing and Drumright oil fields, he opened markets there. He owned what is thought to be the first Cadillac in Stillwater and enjoyed the attention he received while traveling between Cushing, Drumright, and his home in Stillwater.

Hays Hamilton, grocery store owner and original Stillwater Townsite Company member, settled this property in 1889 and operated a vineyard. Prohibitionists, unhappy he was growing grapes for wine, burned down the first home on the property. This home replaced the original and still stands today. Hayes was the driving force convincing residents it would be smarter to vie for the land-grant college and forego attempts to wrest the capital away from Guthrie.

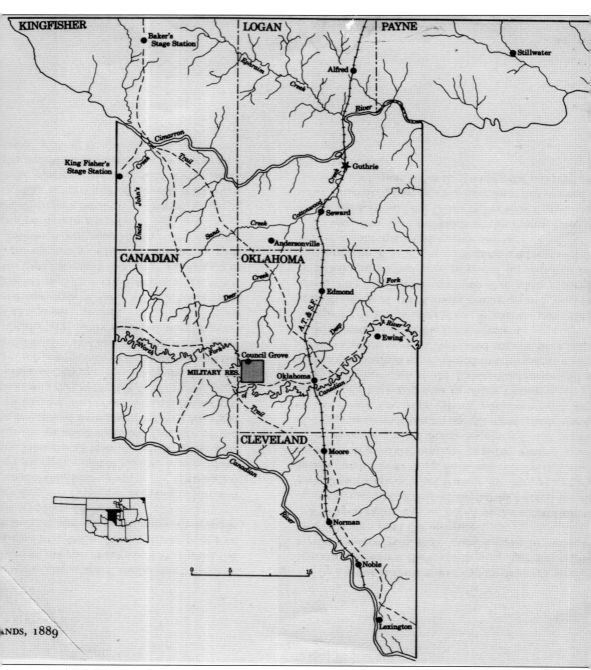

This 1889 map shows how remote Stillwater was. While most of the Unassigned Lands had railroads, trails, and rivers, Stillwater had none. Although this may have impeded the early growth of the new town, it forced the settlers to work harder and think smarter. (Oklahoma Historical Atlas.)

Although he has no namesake streets or parks, few could argue that anyone gave more to Stillwater's early days than Amon Swope. Hailing from Pennsylvania by way of Winfield, Kansas, he came to the two-month-old town of Stillwater in June 1889. He helped lead the campaign to land the county seat of Payne County. His building at Ninth Avenue and Main Street was the hub of many of the new town's activities.

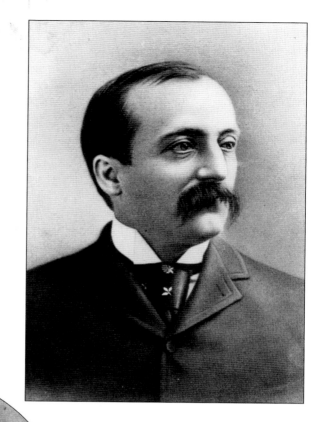

Stillwater, Payne Center, and Perkins were all vying for the county seat. Stillwater sent Frank A. Hutto on a secret mission to Washington, and he convinced Congress to annex five townships to the north into Payne County, giving Stillwater the advantage of being geographically in the center. His success was rewarded, and he was the county's first city attorney.

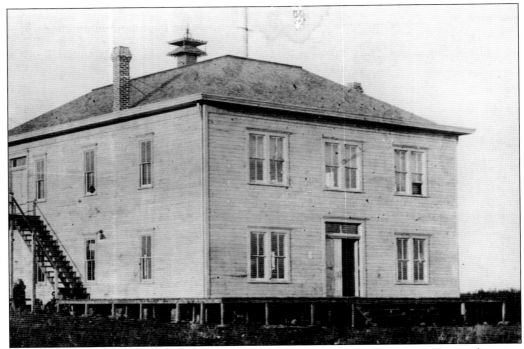

Payne County's first courthouse was built in 1891 after operating for two years in the Presbyterian church. Before it was destroyed by fire on December 26, 1894, it held the memorable trial of Arkansas Tom Jones from the Doolin Gang after the famous gun battle at Ingalls in 1893.

After the first courthouse was lost to fire, this structure was built in 1895. The outside stairs were designed to serve as gallows (although there were no known hangings), and a tin building was used as a jail. There were also pens for bloodhounds used to hunt fugitives.

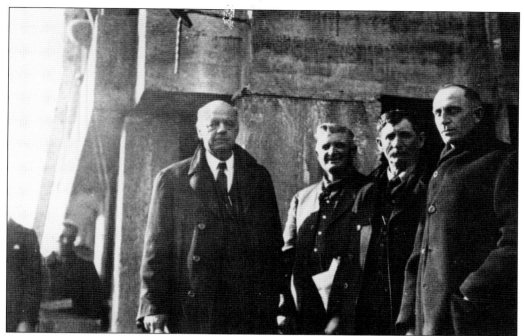

By 1918, the county was gaining population at a rate that the current courthouse could not accommodate. The larger brick structure was being built to serve all the residents of Payne County. Robert Lowry (left) and Chris Holzer (second from left) were helping lay the cornerstone at the new courthouse at the southwest corner of Sixth Avenue and Husband Street. Lowry was quoted as saying, "Except earthquake, cyclone, or bombardment . . . the papers entombed today will not be viewed again for hundreds of years."

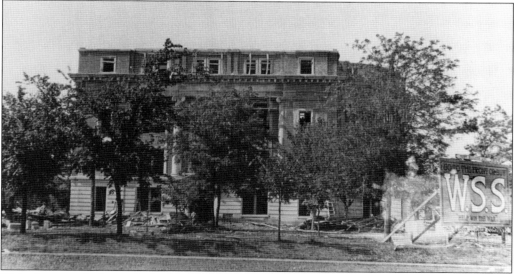

This photograph shows the building under construction in 1918 at 606 South Husband Street. The writing on the bottom of the image indicates that the new courthouse cost $100,000, a tidy sum for the early 1900s. The work to wrest the county seat away from Perkins and Payne Center had paid off in a huge way.

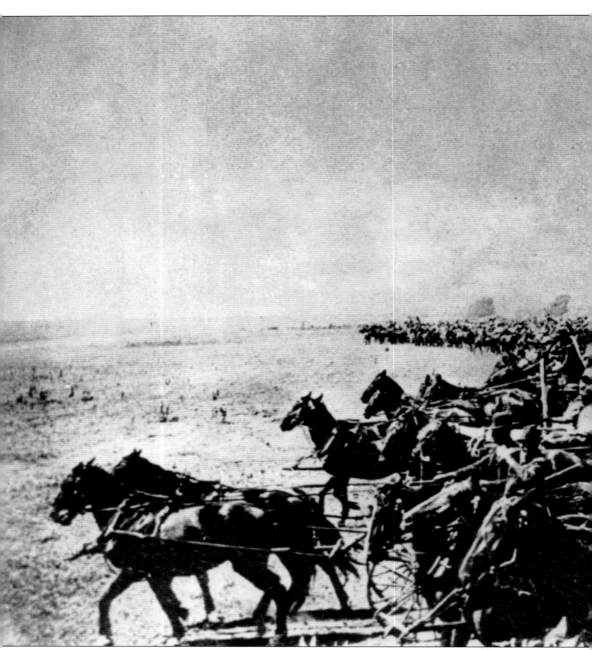

September 16, 1893, may have been one of the most anticipated and exciting days in Oklahoma. Six months earlier, Pres. Grover Cleveland had signed the Indian Appropriation Act to open the six million acres of the Cherokee Outlet, commonly called the "Cherokee Strip." The contrast between the Great Land Run of 1889, which led to the founding of Stillwater, and the land run of 1893 could not be greater. The 1889 run came after 10 years of pent-up enthusiasm by the Boomer movement and resulted in the creation of a new territory. The 1893 run was in the midst of a national depression, a severe drought, and a general distrust of the large ranch holders that were prominent in the area. The 1890s may have been a trying time, but the Populist movement,

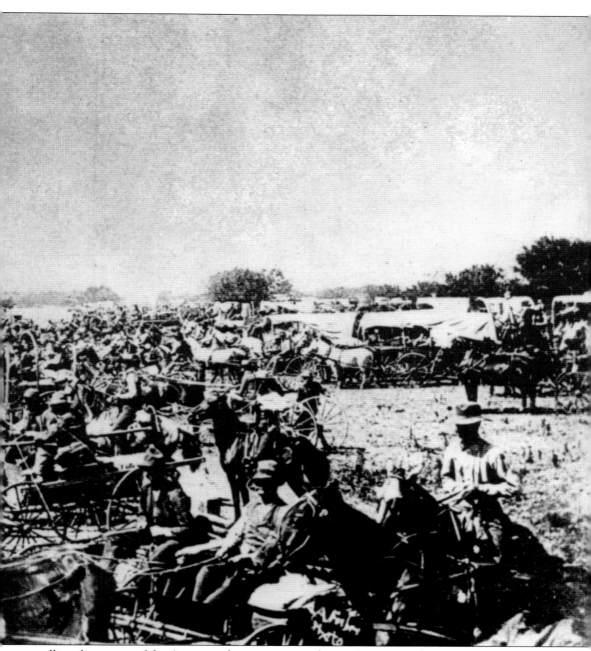

extolling the virtues of the American farmer, convinced over 100,000 people to vie for the 42,000 available claims. This, however, troubled Stillwater, as it was about to lose half of its population in a single day. The promise of a better life in the Unassigned Lands came at a price, and over 600 Stillwater citizens left to seek opportunity several miles north. The 1893 run, however, was limited only to people who had not participated in earlier runs. Due to a robbery of the registration booth at Orlando the night before the run, there were thousands of black market registrants and sooners to claim land in the Cherokee Strip.

A group called the Vigilantes was doing all it could to land a state institution in the fledgling town of Stillwater. The penitentiary, normal school, land-grant college, and even the capital were up for grabs. Seth Hayes Hamilton, a Vigilante, had a vivid dream that Stillwater could and should have the land-grant college, and the others all agreed.

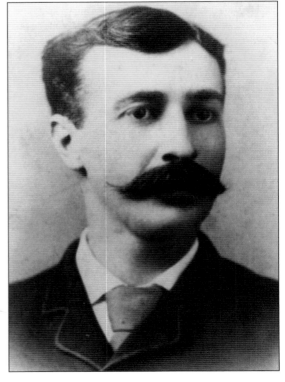

Stillwater barber Charles Knoblock was one of the Vigilantes that fought to get the new land-grant college located in town. He went on to become city clerk and later served as mayor of Stillwater from 1891 to 1892. His credentials were important as he lent his support for the new college. He is the namesake one of Stillwater's more unusual street names.

Six

A SMALL TOWN BECOMES A CITY
THE ROARING TWENTIES TO THE FABULOUS FIFTIES

Excitement soared when, on March 25, 1900, over 750 people rushed to the new depot to hear the first train whistle. Churches suspended worship services so all the residents could participate. The tracks had been laid from Pawnee to Stillwater and on to Ripley.

This was the beginning of real growth. With the railroad, people moved in and started building permanent homes. The growing population required more churches, schools, and of course, more shops. Downtown Stillwater was starting to blossom, with the center of town being at Ninth Avenue and Main Street. The town was bordered by Third Street on the north, Twelfth Avenue on the south, Duck Street on the west, and the railroad on the east. Virtually all shops and businesses were located in this area, mostly along Main Street.

Early stores included New York Racket, Tiger Drug, C.R. Anthony, J.C. Penney, Bonneys, Bates Brothers, Murphy's, Swiler's General Store, Eylers, Douglas' and the iconic Katz Department Store. Hotels included the Youst, Nichols, Going, Rains, Commercial, Pacific, and the Grand. The growing population would need a place to do its banking, and early banks were Payne County Bank, Farmers and Merchants, Citizens, Stillwater State Bank, and the Bank of Stillwater. Doctors' offices, law firms, theaters, and so on also lined the brick streets of downtown.

Many churches were to be built soon after the land run, but the first services were actually held the day before the run, on Easter Sunday. Christian Church minister G.W. Puckett held an Easter service for the law-breaking sooners. All along the border, law-abiding settlers also gathered for prayer and worship, asking for God's blessings.

Soon after the run, churches of various denominations sprang up close to town, including Methodist, Presbyterian, Church of Christ, United Brethren, Congregational, Baptist, and Christian Science. Catholics and Lutherans built nearby.

The growing population required schools to educate the children. September 30, 1889, was the first day of school. The first classes were held on the second floor of the Swope Building, at Ninth Avenue and Main Street. A school building was built at Lewis Street and Twelfth Avenue before a more permanent schoolhouse was erected at Third and Main Streets, considered "north of town." Alcott, Horace Mann, Lincoln, Jefferson, and North and South High Schools followed. The growing city then added Will Rogers—named for Oklahoma's favorite son—Westwood, and Highland Park.

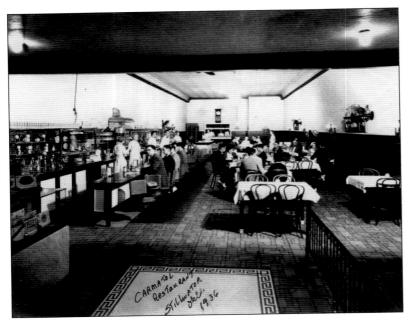

The "place to see and be seen" during the Depression years of the 1930s was the elegant Carmatolle Restaurant, located in the Grand Hotel at the corner of Sixth Avenue and Main Street. Opening in 1933, it was named after its co-owners, Floyd Carmain and Proctor Tolleson.

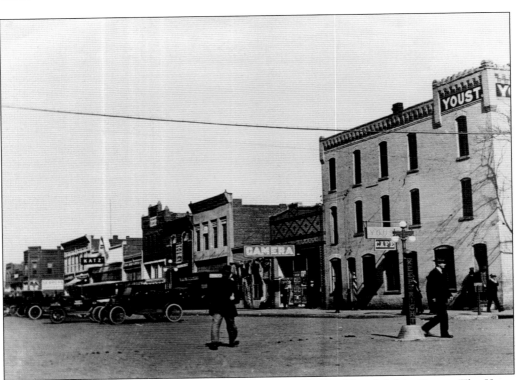

This is a great photograph of the west side of the 700 block of South Main Street. The Youst Hotel dominates the corner. Visible are the Camera Theater next door and, on its other side, the B&O Bakery. Katz Department Store is located on the west side before moving to the southeast corner of Seventh Avenue and Main Street.

Dr. William Claten Whittenberg built Stillwater's first hospital. Although known for his love of dogs and hunting, another aspect of his character is more noteworthy. During the Depression, his nurse of 15 years, Anna Ferguson, was quoted as saying, "Dr. Whittenberg knew they were 'hard up,' feeling sorry for them, he often never charged them anything."

Dr. Whittenberg solicited the help of eight nurses to operate the new hospital. When the entire team of nurses became ill during the 1918 flu epidemic, volunteers pitched in to help. These nurses, from left to right, are Maude Brower, Beaulah Roether, Edith Olmstead, Katherine Bandelier, Harriet Barnes, Juanita Geller, Ethel McPherson, and Leota Amick.

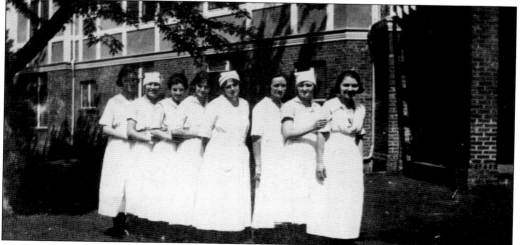

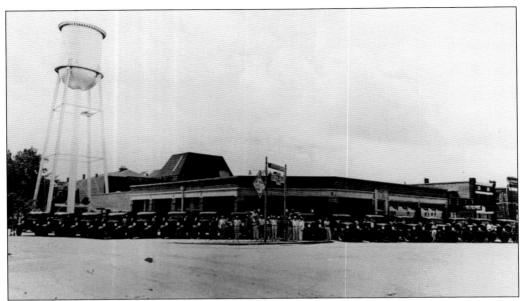

After working for the Jewett-Graham-Paige Agency, Richard Stanley Ward opened his own Chevrolet agency at Ninth Avenue and Husband Street in the former Sellers Livery Barn. This was the location built in 1934. This photograph shows 16 trucks just delivered for the US Department of Interior for Soil Erosion Service camps.

First National Bank had grown into a regional banking institute and continued to need more space. This third building was constructed in 1924. It served for the next 40 years before it was demolished and the newer, larger, more modern version was erected.

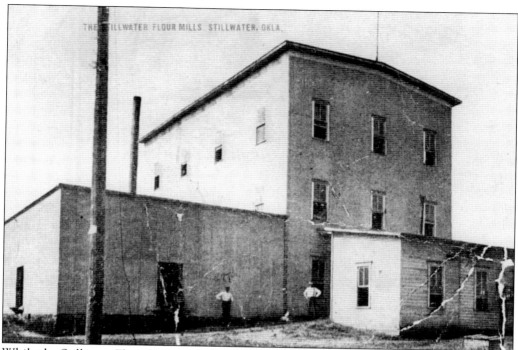

While the Stillwater Flour Mill was built in 1909, it has had many additions since its beginning on East Sixth Avenue. Constructed by Charles Babcock, who also owned a retail establishment downtown, it became part of a much larger complex that included a cotton gin and grain elevators. The famous "A&M" logo at the very top of the grain elevators for many years did not stand for Oklahoma A&M, as most thought, but for the new owners, husband and wife Andy and Mandy Goodholm. (Author's collection.)

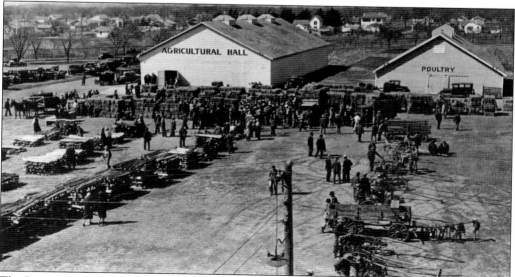

The Payne County Fairgrounds have been a major part of Stillwater's history for many years. The fairgrounds were located in Couch Park, near the original Boomer Camp, from 1915 until 1971, when they were moved two miles east of town.

71

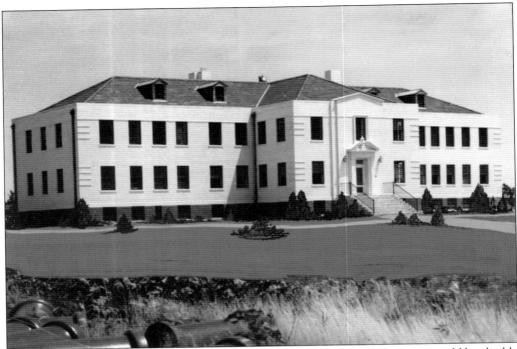

Miraculously, this Stillwater hospital was designed and built in only 30 days so it would be eligible for federal funds in 1939. It began with only 40 beds but quickly needed more. In 1949, a third floor with another 45 beds served the needs of the community until a new, modern hospital was built on Sixth Avenue in 1976, becoming a regional medical center.

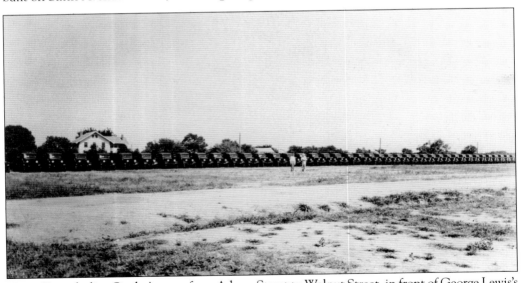

Here, 50 trucks line Sixth Avenue from Adams Street to Walnut Street, in front of George Lewis's farm, as Ward Chevrolet delivers them to the federal government. The government routinely ordered fleets for soil-conservation efforts, direly needed in Oklahoma during the 1930s. The house in the background is the Lewis farmhouse, which stood until the 1990s, when it became the site of medical offices.

This advertisement, promoting the virtues of owning a Studebaker automobile, joins many other ads from the 1949 Stillwater city directory. Other automobile dealers from the early days include Harley Thomas Ford, father of current Ford dealer Owen Thomas; Barnett Motors, selling both Nash and Studebakers; Bryan Motors, selling Cadillac, Olds, and GMC; Ward Chevrolet and Buick; Barnes and Goble Chrysler-Plymouth; Simpson Pontiac; and Hull Motors, selling Dodge cars and trucks, among others.

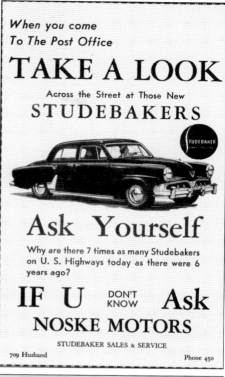

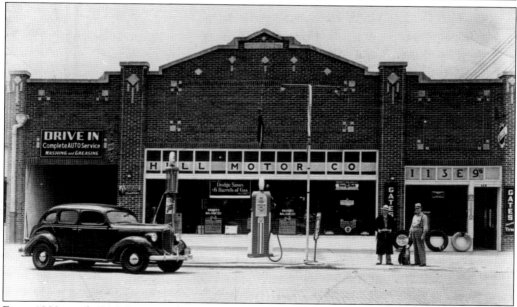

From 1889 until 1926, Louis and Lon Myers operated a livery barn at 113 East Ninth Avenue. After Louis Jardot and his son Harold, with the help of a handful of others, removed the barn and built this "modern" brick structure, it was reincarnated into an automobile dealership. After stints as Stillwater's first undertaker, and then a Hupmobile and Whippet dealer, Clarence Hull opened Hull Motor Co. in the new building and sold Dodge cars for many years.

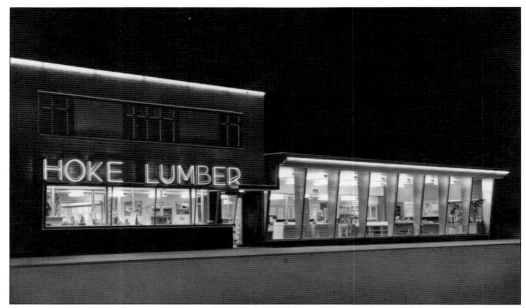

Built in 1928, Hoke Lumber served the needs of Stillwater as its largest lumberyard and was instrumental in the building of many homes in town. This building at 213 East Ninth Avenue was destroyed by fire in 1980. Roy T. Hoke was one of Stillwater's most beloved philanthropic and civic-minded citizens for much of the 20th century. Born in Quay (near Yale), he attended OAMC prep school before starting his business career.

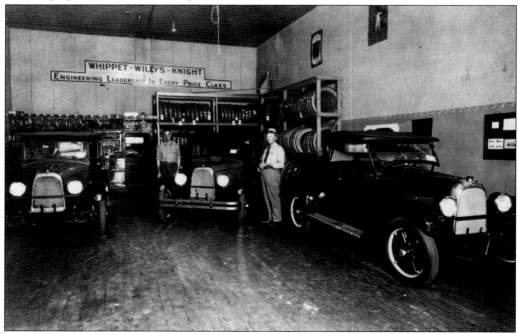

Before opening the Dodge agency in 1926, Clarence Hull operated this Whippett-Willys-Knight agency in the early 1920s with Frank C. Schedler at 722 South Main Street. He moved the dealership to 116 East Sixth Street, shown here.

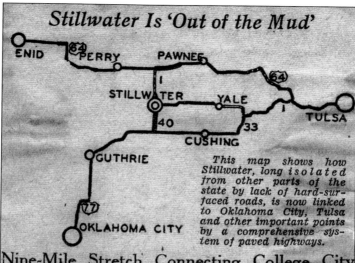

Stillwater Is 'Out of the Mud'

This map shows how Stillwater, long isolated from other parts of the state by lack of hard-surfaced roads, is now linked to Oklahoma City, Tulsa and other important points by a comprehensive system of paved highways.

Nine-Mile Stretch Connecting College City And Capital Connected by Pavement.

STILLWATER, June 20.—(Special.) —Stillwater at last is "out of the mud."

Visitors who motor to the agricultural capital, otherwise known as the home of Oklahoma A. and M. college and the Payne county seat, no longer will have mud or dust as they approach their destination. The last gap is paved. All of it will be opened to traffic by June 26.

Completion of paving in state highway No. 40, a nine-mile stretch immediately south of Stillwater, provides an unbroken line of paving from Stillwater to Oklahoma City and connecting points, and in a round-about way, all-paved roads may be traveled between Stillwater and Tulsa.

State highway No. 40 connects with No. 33, nine miles south of Stillwater, No. 33 being the Oklahoma City-to-Tulsa route. The direct Stillwater-to-Tulsa road is state highway No. 1, by Yale and connecting with No. 33 at Oilton.

PAVING of the stretch has been an urgent desire of Stillwater citizens since Payne county voted $1,000,000 in road bonds in 1926, but for various reasons it was left as almost the last project in which joint county and state funds are used.

No. 40, outlet to the south, may be chosen for beautification by the state as a model of other paved roads in Oklahoma.

At the request of A. R. Losh, state highway engineer, Christian Jensen, Stillwater landscape expert, has prepared plans for the section's beautification. Jensen was asked to select a section of highway and to prepare the plans. Formal acceptance of his work is expected.

Featuring Jensen's proposal is the suggestion that a monument to Capt. David L. Payne, the intrepid "boomer" for whom Payne county was named, be erected at the intersection of state highways No. 40 and No. 33, nine miles south of Stillwater.

JENSEN estimates that a suitable memorial to Payne would cost $5,000. The Stillwater chamber of commerce has a committee actively investigating the possibility of raising that much money.

In the beautification of No. 40, native trees and shrubs would be planted along the roadside, signboards would be removed, telephone poles would be set back and minor buildings near the road would be altered to blend with the general scheme. Small roadside parks would be maintained.

New Negro School Planned—Luther school board Monday is scheduled to let contract for construction of a new Negro school to replace the one destroyed several months ago by fire. Bids were received Friday with Secor Construction Co. apparently low with an offer of $34,900.

The headline reads, "Stillwater Is 'Out of the Mud.' " Stillwater may have finally gotten a railroad, but paved roads would take much longer. It was not until 1931 that Stillwater got a paved way out of town, as Highway 40 (now 177) was finally completed, connecting residents to Highway 33 near Perkins with connections on to Guthrie, Oklahoma City, and Tulsa. Today, there are major four-lane highways in all directions, with the Cimarron Turnpike connecting the city with Tulsa. (Author's collection.)

Jake Katz remained a Stillwater fixture for most of the 1900s. His store, Katz Department Store, was on Main Street for over 100 years. Other members of his family also had notoriety in the business world. His son-in-law Sylvan Goodman ran several grocery stores with half interest in the Piggly Wiggly stores before buying the Humpty Dumpty chain. In 1937, Goodman invented the world's first shopping cart as a means of boosting sales, and it was a major success.

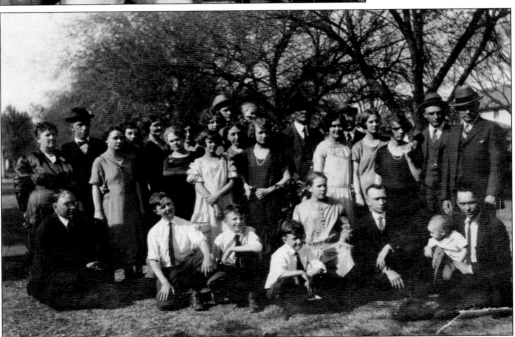

The Donarts are one of Stillwater's most prominent families. Charles Donart homesteaded during the 1889 land run near Couch Park. This reunion photograph was taken in 1930. Charles's son served as the school board clerk for many years and was honored with the naming of C.E. Donart High School from 1960 until 1982, when the school resumed its original name, Stillwater High School.

The 600 block of South Main is teaming with business in this 1930 photograph. Familiar names along this block are Jack Washinka's Jewelry, the Piggly Wiggly grocery, and the stately Grand Hotel, owned by Art Scroggs. Art's grandson Danny Scroggs operates a shop called Peck's Lodge in the historic building of the same name at University and Knoblock Streets.

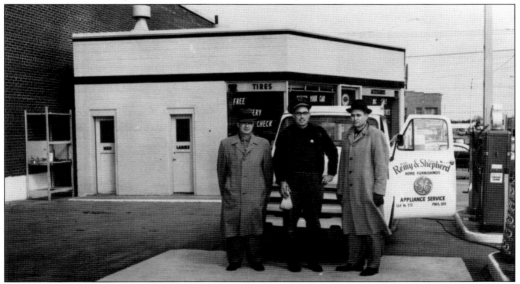

Cleo Harris (center), owner of the Phillips 66 service station at Sixth Avenue and Husband Street, is flanked by Ralph Remy (left) and Jim Shepherd. Remy and Shepherd owned and operated the successful Remy-Shepherd Home Furnishings at 116 East Ninth Avenue, continuing the tradition of having a furniture store on the first floor of the opera house built in 1900. Furniture, along with antiques, is still sold in the same building 125 years later.

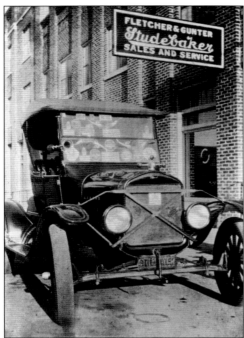

Although parked at the Fletcher and Gunter Studebaker Agency, Marion Karr's automobile is actually a 1925 Ford Roadster. The front windshield is practically covered with decals. Note one decal that says, "Girls, Hop in Here." This Studebaker dealership was at the rear of the Grand Hotel at Sixth Avenue and Main Street.

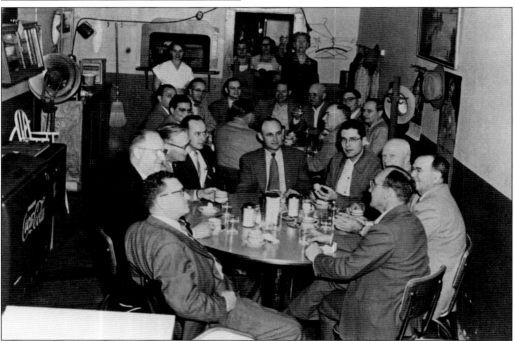

Businessmen gathered for coffee at Kate Montgomery's Service Café. At the first table are Clarence Cowen, Leroy Crossman, Red Alcott, Frank Berry, Walter Hoss, Warren Cooke, Dean McElroy, Roy Hoke Sr., and Marsden Bellatti. The second table holds Morris Gershon, Orville Mayfield, Floyd Turner, Kenny Gallagher, Glenn Varnum, Les McConkey, Burton Dix, Harley Thomas, Herb Loyd, and Vernon Stark. Owner Kate Montgomery stands in the rear.

Seven

OAMC

HOME OF THE TIGERS?

The arduous fight to win the land-grant college was arguably the biggest coup for the fledgling town. On December 14, 1891, Stillwater School principal Edward Clark picked 12 of his brightest students from the high school to be joined by 33 others as the first students at OAMC. There were 23 girls and 22 boys attending the first day of classes at Oklahoma Agricultural & Mechanical College. With no buildings for classes, these students met at the First Congregational Church. As the school grew, other churches and the courthouse were also used. As James Homer Adams, one of the Stillwater students, said later, "Not only had we washed our necks, we scrubbed behind our ears, and our overalls were freshly washed and ironed." Some seemed surprised to be led in prayer, taught scriptures, and given a sermon. Although he admitted not knowing exactly what he was being asked to do, James Adams, at 13 years old, signed the register, officially becoming OAMC's first student. None of the students had finished high school, so they were enrolled in a college preparatory curriculum.

The next milestone for the college was the June 15, 1894, dedication of the Assembly Building. Now known as Old Central, it contained 16 classrooms, offices, and an assembly hall. This space relieved the many churches and the courthouse that were holding classes. At the event, the speaker promised there would be more and larger permanent buildings to share the prairie. By 1900, four others had been built, with many more to follow.

Some ambitious leaders of the college, along with some leaders of the town, encouraged growth by declaring OAMC "Princeton on the Prairie." From its Georgian architecture to its mascot name and colors (orange and black), OAMC was now, just like Princeton University, home of the Tigers, although many also referred to them as the OAMC Aggies. In 1957, the success of the college brought a new era, and a name change to Oklahoma State University, home of the Cowboys, was met with much applause. The mascot changed from the tiger to Pistol Pete, though some still proudly consider them the OSU Aggies.

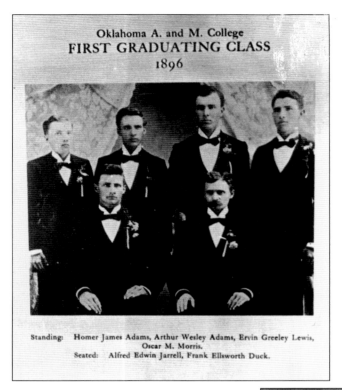

Oklahoma A. and M. College
FIRST GRADUATING CLASS
1896

Standing: Homer James Adams, Arthur Wesley Adams, Ervin Greeley Lewis, Oscar M. Morris.
Seated: Alfred Edwin Jarrell, Frank Ellsworth Duck.

This is the first graduating class of 1896. These six men, dressed in tuxedos, each gave a speech and were presented flowers at commencement. Seated are Alfred Jarrell (left) and Frank Ellsworth Duck (right), who donated 40 acres to help establish the college. Standing are, from left to right, James Adams, Arthur Adams, Ervin Lewis, and Oscar Morse.

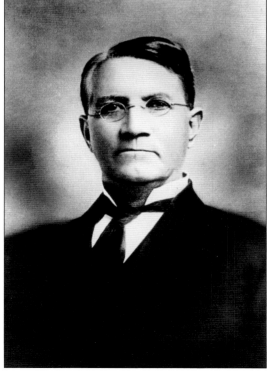

Robert J. Barker, OAMC's first president, never lived in Stillwater. He had homesteaded 42 miles southeast, staking his claim near Crescent in the 1889 land run, and was afraid that if he moved to Stillwater, he would lose his claim. He served as president from 1891 through 1894, overseeing construction of Old Central.

Speech professor Howard Seldomridge, known as "Seldy," had a dream: to see Victor Herbert's operetta *The Red Mill* in New York. While the cast sang "In Old New York," the audience waved their arms in unison, and he was inspired. Returning to Stillwater, he penned new lyrics to the song, naming it "O.A.M.C." It became the college's official song. Most OSU faithful think the waving wheat in the state song, "Oklahoma!", inspired the tradition of waving their arms, but in reality, the practice was inspired by an operetta in New York.

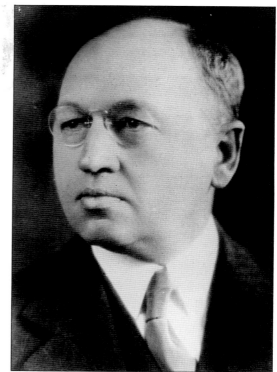

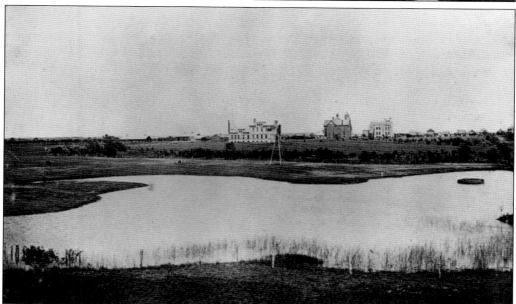

Theta Pond was originally a watering hole for cattle, as well as the campus's first source of drinking water. Since the 1890s, it has been a popular place for studying and relaxing. If one were fortunate enough to become engaged while at school, tradition dictated that the groom-to-be would be thrown into the pond. The benches around the pond became a popular spot for popping the question, as the author's father did in November 1948. (Author's collection.)

Frank B. Eaton was a colorful man: a cowboy, an Indian fighter, a deputy US Marshal, and quite a character. He became a sought-after storyteller in his later years. After seeing Eaton, known as "Pistol Pete," students approached him about becoming the mascot. They secured his likeness to become the new OAMC official mascot, and the name of the athletic teams also transitioned to the Cowboys (also known as the Aggies). The only constant from 1890 until today are the colors, orange and black. (Author's collection.)

The likeness of Frank Eaton, "Pistol Pete," has been used by OAMC, now Oklahoma State University, for over 90 years. Before OSU secured a trademark on the likeness, two other universities began using Pistol Pete (with minor variations), the New Mexico State University Aggies and the University of Wyoming Cowboys.

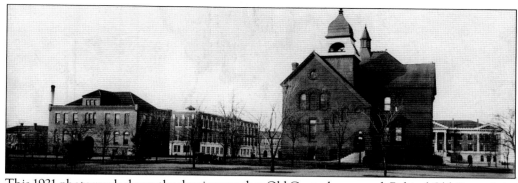

This 1921 photograph shows the dominance that Old Central possessed. Behind Old Central sits Morrill Hall (named in honor of the Morrill Act, which established land-grant colleges), rebuilt after being gutted by a 1914 fire. Gardiner Hall sits to the right of Old Central, with Gunderson to the left. Old Central has been painstakingly restored to its original glory and is now home to the Oklahoma State University Honors College.

FINAL AFFIDAVIT REQUIRED OF HOMESTEAD CLAIMANTS.

SECTION 2291 OF THE REVISED STATUTES OF THE UNITED STATES.

I, Frank B Eaton, having made a Homestead entry of the E½ NE¼ Section No. 11 in Township No. 17 N of Range No. 2 E, subject to entry at US Land Office Guthrie OT under section No. 2289 of the Revised Statutes of the United States, do now apply to perfect my claim thereto by virtue of section No. 2291 of the Revised Statutes of the United States; and for that purpose do solemnly Swear that I the head of a family over 21 years of age, a Native born citizen of the United States; that I have made actual settlement upon and have cultivated and resided upon said land since the 1st day of April 1890, to the present time; that no part of said land has been alienated, except as provided in section 2288 of the Revised Statutes, but that I am the sole bona fide owner as an actual settler; that I will bear true allegiance to the Government of the United States; and, further, that I have not heretofore perfected or abandoned an entry made under the homestead laws of the United States, except

(Sign plainly full christian name.) Frank B Eaton

I, Thos H Corbett Receiver, of US Land Office at Guthrie OT, do hereby certify that the above affidavit was subscribed and sworn to before me this 7 day of September, 189 5, at my office at Guthrie O in Logan County, OT.

Thos H Corbett
Receiver

Frank Boardman Eaton, also known as "Pistol Pete," was born in Connecticut on October 26, 1870. At 29, he joined the land rush and settled southwest of Perkins. Eaton was a successful blacksmith, sheriff, US Marshal, cowboy, Indian scout, and author, but his real claim to fame came when OAMC students spotted him at Stillwater's 1923 Armistice Day Parade. Looking for a new OAMC mascot to replace the oft-maligned Tiger, they thought Pistol Pete would be the perfect mascot to lead the school's athletic teams into the future. They were right, as Pistol Pete is one of the nation's favorite college mascots. Eaton died in Perkins in 1958.

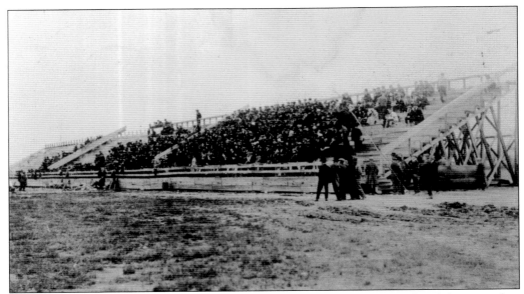

This September 1920 photograph was taken just before the OAMC Tigers played their very first game in the stadium. The Tigers failed to win a game that year. Lewis Field has been transformed into the 60,000-seat Boone Pickens Stadium, and the team has become a national power, now in the Big 12 Conference, after starting in the Missouri Valley Conference.

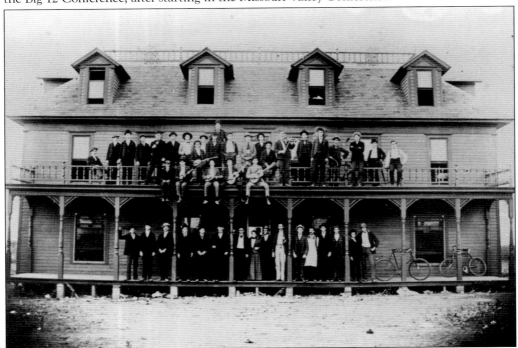

For only $2 per week, male students could get room and board at the College Boarding Club. Privately owned by J.T. Land, the building was rented by the residents, who organized the facility for their specific purposes. Although it was not a college-owned dormitory, it quickly took on a dormitory atmosphere.

Eight

OKIES TAKING A BREAK
YOST LAKE TO THE PICTURE SHOW

Early days in the new frontier were filled with much hard work and long hours. The men tended to the fields, took care of livestock, or worked as doctors, lawyers, and shopkeepers. The women worked equally as hard, making sure the home was kept up, all without the luxury of electricity and modern appliances. All this hard work made it necessary to find outlets for relaxation with friends and family.

Yost Lake, built as a watering hole for steam engines, served the railroad between Pawnee and Stillwater. A small town of sorts developed around the lake, with a post office serving the community between 1901 and 1905. With the demise of steam locomotives, the lake was no longer needed. In 1901, Robert Lowry obtained a lease of the area and developed a sort of country club for Stillwater's residents. He ran the Doodlebug Railroad to the lake and charged 10¢ for the ride. Once at Yost Lake, there was swimming, tennis, and later, golfing during the day and evening dances and parties. Owning a cabin was a status symbol for Stillwater residents.

Stillwater became a mecca of fine theaters. Early theaters were often short-lived. The first was the Pastime, at 612 South Main Street. Three years later, Herbert Ricker, Stillwater's first automobile dealer, bought and moved it to 915 South Main Street, renaming it the Gem. It was subsequently bought by the fire department and renamed Fireboy, with proceeds buying firefighting equipment.

The Alamo opened at 914 South Main Street in 1908 and was Stillwater's first luxurious theater. Louis Jardot's Grand Opera House at 116 East Ninth Avenue was built in 1900 for stage shows and live entertainment, but it began showing movies in 1910. The Camera was built in 1914 and was followed by the Garden, which became the Abbott, then the Mecca. Brothers Claude and Oakley Leachman joined forces with Griffith Entertainment and opened the Aggie at 619 South Main Street. For two decades, this would be Stillwater's most popular entertainment spot. Later, the Leachman would anchor the north end of downtown at 424 South Main Street, and the Campus Theater would serve the college students at Campus Corner, University and Knoblock Streets.

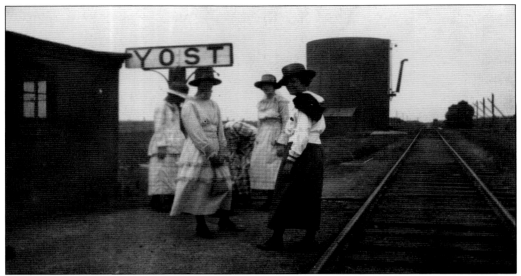

Yost Lake was a favorite recreation spot for the citizens of Stillwater. Since Robert Lowry founded Yost Lake Country Club, his daughters were frequent visitors to Yost Lake. From left to right, Fern, Abigal, Ethel, and Theodora Lowry all wait for the Doodlebug, the train that ran between Yost and Stillwater, for a one-way fare of 10¢. Behind the girls sits the original wooden water tower to provide the steam locomotives their much-needed fuel.

In this 1914 photograph, the original pavilion is crowded with country club members. Although it has had its ups and downs, the lake and club have been a popular retreat for over 114 years. The shores of the lake are now lined by 61 cabins.

Stillwater may have only been a fledgling town of 300, but that did not stop residents from having a community band. Many of the early pioneers volunteered their time to provide enjoyment for the community. Some prominent faces include Clarence Donart (first row, left), Dr. Murphy (first row, third from left), M.W.J. Holt (first fire chief, second row, second from left), Arthur Adams (from the first OAMC graduating class of six, third row, left), and Harry Donart (one of Stillwater's first teachers, third row, fifth from left). (Barbara Dean and Ruth Donart.)

While not the most beautiful spot in town for a swimming pool, this was popular site nonetheless. It was located on East Sixth Avenue, and the flour mill loomed large over its shoulder. The smell of the mill was often apparent, but that did not stop children (including the author) from cooling off on a hot summer day.

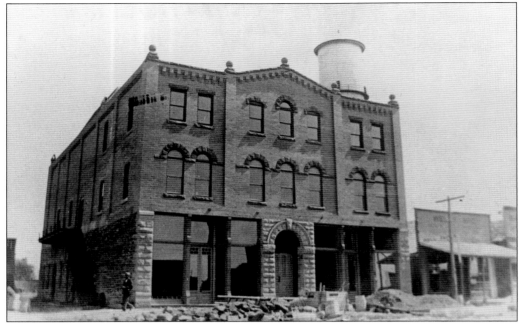

Louis Jardot built one of the territories' grandest entertainment venues in 1900. The brick was all made in Stillwater at Jardot's brick plant. The Grand Opera House opened to much success, with vaudeville acts, lectures, musical performances, and other live entertainment. William Jennings Bryan made a rousing speech from the stage. Prohibitionist Carrie Nation sold small hatchets for 50¢ each, after her speech, to raise money for her anti-liquor cause. During and following World War I, there were many patriotic parades. This 1917 parade is lead by a Model T, but it is dragging because of the many soldiers and weapons on board. Popular businesses that can be seen are the Youst Hotel, the Camera Theater, Katz Department Store, Searcy's Grocery, and Bishop's Menswear across the street.

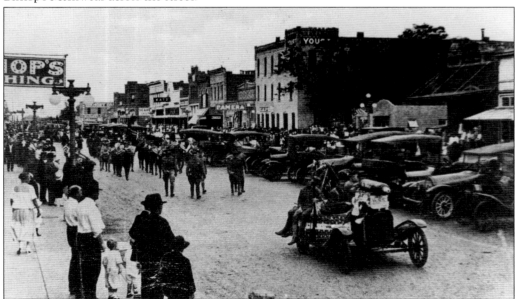

Eminent domain was not a term many had heard of in the 1930s, but the Roy Thompson family learned about it the hard way. Their farm and homestead was soon to be inundated with water to make way for the new Lake Carl Blackwell. The lake became a popular spot for skiing, fishing, camping, and enjoying the water.

Built in 1937, the Resettlement Lodge and Bath House was to be the centerpiece of a recreation and entertainment area complimenting the soon-to-be-completed Lake Carl Blackwell. Shortly before the celebrations were to begin marking the opening of the new lake and lodge, it burned to the ground. It has been rumored that it was arson, perpetrated by a disgruntled farmer who had lost his land by eminent domain for the creation of the lake. (Author's collection.)

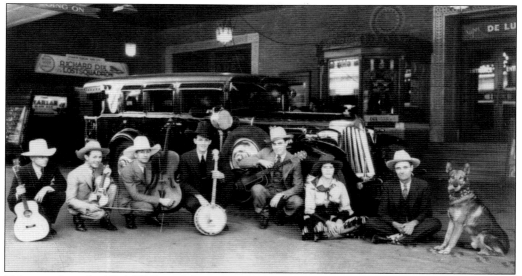

Tulsa may have had Bob Wills and the Texas Playboys, but Stillwater had an equally famous band, Otto Gray and the Oklahoma Cowboys. They rose to fame in 1926, when *Billboard* magazine featured them. Gray, born in 1884, came when his parents homesteaded during the 1889 land run. Their claim was a few miles east of Stillwater and is now the site of Dale Clouber's Washington Irving Trail Museum. When Otto Gray traveled, he did so in style, spending over $100,000 annually and, as the poster says, going coast to coast "in a caravan of special custom built cars and trailers." The small print says he was affiliated with NBC Artists' Bureau. At the far right are Otto and his dog Rex, billed as "the Wonderful Police Dog." During the radio shows, Rex would bark to music's rhythm, also becoming known as the "Bark of the Radio."

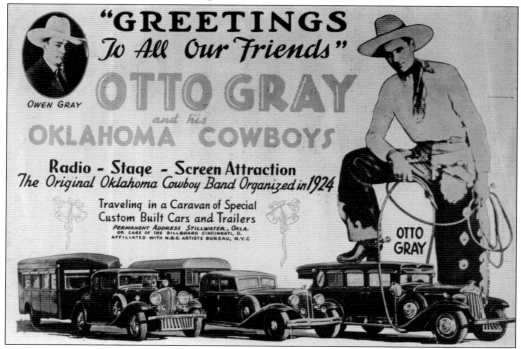

Built in 1926, the Aggie Theater (called after a nickname for the college's students) became Stillwater's most popular entertainment venue. It burned to the ground, but 11 months later, on December 21, 1948, it would reopen. The 1926 Aggie had been ahead of its time, with a fireproof projection room, a soundproof "crying baby room," and a soundproof "party room" for large groups. The fire was doubly devastating since all of the equipment and furniture for the soon-to-be-opened Leachman Theater was being stored above the Aggie.

The 1930s brought an influx of provocative movies that were promoted for teaching moviegoers the "mysteries of sex." Here at the Mecca, there were separate showings for men and women. The poster invites audiences to come and "see the picture that made them throw apples at Eve." An unidentified girl seems to be trying to see what all the fuss is about.

From Pawnee, Oklahoma, 28 miles northeast of Stillwater, Gordon W. Lillie was a larger-than-life character known as "Pawnee Bill." After moving from Illinois to Kansas, he befriended the Pawnee Indians, who brought him to Pawnee. After a stint as leader of the Boomer movement, he worked with Buffalo Bill; the two eventually joined forces to form Buffalo Bill's Wild West and Pawnee Bill's Great Far East Show. He is shown here in 1940, attending Stillwater's Aggie Theater to see *Waterloo Bridge*. The Pawnee Bill Mansion and Museum is a must-see attraction in Pawnee County.

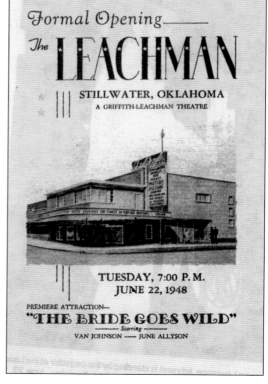

After opening theaters in Woodward and Blackwell, Claude and Ralph Leachman joined forces with Griffith Entertainment to open new, larger theaters in Stillwater. Following the devastating fire at the Aggie, plans were ramped up to open the ultra-modern and luxurious Leachman Theater at 424 South Main Street. It held its formal grand opening on June 22, 1948, to much acclaim.

Nine

It Happened Here First
Sonic and Other Stillwater Start-ups

The people that settled in Stillwater needed to be tough, dedicated, and innovative. To develop a town without the much-needed assets of railroads, highways, or bridges, they had to rely on their own wits to overcome the adversities. The innovative spirit of Stillwater's first residents carried on through future generations.

Many agricultural, engineering, aeronautical, scientific, and agricultural innovations and advances have been accomplished in Stillwater and on the campus of OAMC. The relationship between Stillwater and the university has contributed greatly to this spirit of innovation.

Among the longest-running agricultural research projects in America (and the oldest west of the Mississippi), the Magruder Plots, at the Agronomy Research Station, have provided scientists valuable insights into wheat research and soil-fertility methods. A.C. Magruder, an agronomy professor, started research on the plot in 1891, and it is still, 124 years later, providing valuable research into soil fertility. Dr. Billy Bob Tucker, longtime researcher in charge and Oklahoma State University regents professor (and the author's father) was instrumental in placing the Magruder Plots in the National Register of Historic Places in 1979.

A surprise to many, an important Civil War battle (the territory's first) known as the Battle of Round Mountain was fought a few miles east in 1861. A divisive faction of 2,000 Creek Indians, led by Chief Opothle Yahola (Hopoeithleyahola) was defeated by Confederate forces and fled to Kansas.

One Stillwater invention is both loved and despised worldwide. Prof. H.G. Thuesen and former OAMC student Gerald Hale designed and built the world's first parking meter in 1933. As cities sought a way to increase revenue and limit parking time on downtown streets, the parking meter was the answer.

Stillwater has played an important role in the music industry. From being the home of America's first cowboy band, the Otto Gray Band, to being the birthplace of red dirt music, Stillwater also saw the launching of Cross Canadian Ragweed, Red Dirt Rangers, All-American Rejects, Jimmy LaFave, the Great Divide, and its most famous, Garth Brooks.

Among many important local innovations were the tornado/emergency siren concept, bomb shelters, and life-saving inventions for livestock. However, one of the most talked-about firsts is the location of the first Sonic, "America's Drive-In." While some say Shawnee, Oklahoma, had the first, the story is a bit more complex. There was a new chain of drive-ins named Top Hat. The first location at Shawnee, then Woodward, and the new restaurant at 215 North Main Street in Stillwater would soon be changing the name to Sonic, with Stillwater the first to receive the new moniker. Thus, Stillwater became home to America's first Sonic.

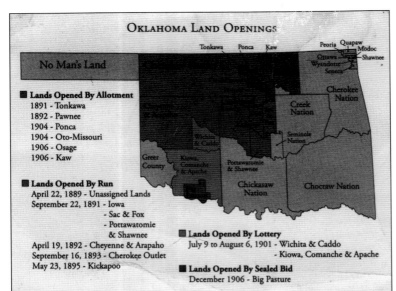

Oklahoma Land Openings

No Man's Land

■ **Lands Opened By Allotment**
1891 - Tonkawa
1892 - Pawnee
1904 - Ponca
1904 - Oto-Missouri
1906 - Osage
1906 - Kaw

■ **Lands Opened By Run**
April 22, 1889 - Unassigned Lands
September 22, 1891 - Iowa
 - Sac & Fox
 - Pottawatomie
 & Shawnee
April 19, 1892 - Cheyenne & Arapaho
September 16, 1893 - Cherokee Outlet
May 23, 1895 - Kickapoo

■ **Lands Opened By Lottery**
July 9 to August 6, 1901 - Wichita & Caddo
 - Kiowa, Comanche & Apache

■ **Lands Opened By Sealed Bid**
December 1906 - Big Pasture

Tonkawa Ponca Kaw Peoria Quapaw
 Modoc
 Ottawa Shawnee
 Wyandotte
 Seneca
 Cherokee
 Nation
 Creek
 Nation
 Wichita
 & Caddo Seminole
 Nation
Greer Kiowa,
County Comanche Pottawatomie
 & Apache & Shawnee
 Chickasaw Choctaw Nation
 Nation

The Great Land Run of 1889 was America's first. Never before had land been divided and prepared for settlement in this manner. This map shows the area of the 1889 land run in the center (Unassigned Lands), along with subsequent runs, allotments, lotteries, and sealed bids. (Author's collection.)

Shannon Feed Company, at 1001 South Main Street, became a huge success after its owner, L.D. Shannon, developed a "dated" feed, giving the consumers the knowledge of the age of the feed they were buying. After expanding to Tulsa, he promoted his company with the daily *Shannon Shamrocks Music Hour* heard on KVOO radio. Oilman W.G. Skelly bought the station in 1928 and helped launch the careers of Bob Wills and the Texas Playboys. The Shannon Shamrocks continued their 9:00 a.m. show for several years. (Dale Clouber.)

Because of hostilities between the Confederate States of America and the United States, Native Americans were forced to align with the North or the South. Most chose to support the Confederacy, but some, led by chief of the Upper Creeks Hopoeithleyahola (Opathle Yahola) favored the North. He recruited Unionists from various tribes, along with African American slaves and freedmen wanting a way out of the South. He led an exodus consisting of 1,700 men, women, and children to Kansas. On November 19, 1861, Douglas Cooper, below, and his Confederate troops, made up of Texas Cavalry bolstered by Choctaw, Cherokee, Chickasaw, Creek and Seminole warriors, were surprised by Yahola's wagon train, and a battle ensued. Cooper's claim of killing over 100 Unionists while only loosing a few of his own men is debatable. (Right, Credit Bureau of American Ethnology, Smithsonian Institute.)

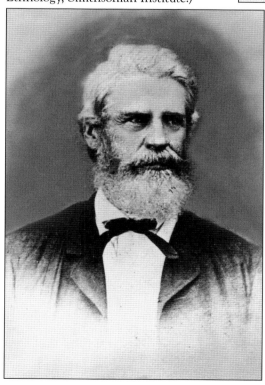

This photograph shows Oklahoma State University regents professor of soil science (and father of the author) Billy Bob Tucker standing next to the monument marking the Magruder Plots, one of America's longest-running agricultural research projects. Dr. Tucker was instrumental in placing the Magruder Plots in the National Register of Historic Places in 1979. Dr. Tucker passed away on June 4, 2014, proclaiming his love of OSU, the Magruder Plots, and his birthplace, Sweetwater, Oklahoma, until the day he died. He will be greatly missed. (Author's collection.)

The world's first parking meter was developed in Stillwater on the OAMC campus. George Theusen and Gerald Hale developed this contraption to ease parking concerns and raise revenue for cities across the world. The first meter was installed at First and Robinson Streets in Oklahoma City on July 16, 1935. (Author's collection.)

Dr. Herbert L. Jones, also known as "Cyclone Jones," was a pioneer in tornado research at Oklahoma State University from 1946 to 1970. After the 1947 Woodward tornado that killed more than 100, he was inspired to help save lives. Working closely with the US Weather Bureau and Air Force Weather Service, his sferics-based tornado-identification and -tracking methods were hailed by the national press as a huge step toward the realization of a public warning system based on accurate information. He is shown here at left with fellow researcher R.D. Kelly. (Oklahoma State University Special Archives.)

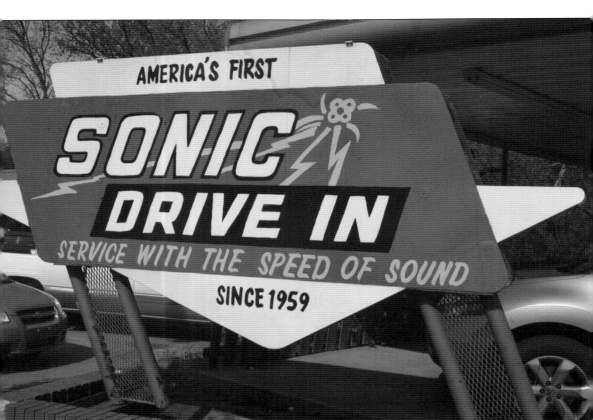

This sign marks the location of the first Sonic in America. It was built in 1958 as the third Top Hat Drive-In and received the new name, Sonic, in the following year. Starting with this initial restaurant, there are now more than 3,500 sites in 43 states. This first restaurant was owned and managed for many years by the Longworth family. As in many small towns, "draggin' Main" was a favorite pastime in Stillwater, and it included circling the Sonic on the south end and A&W Root Beer on North Boomer Road. (Author's collection.)

Ten

THEN AND NOW
AND WHAT A DIFFERENCE!

Stillwater had very humble beginnings. From the day of the land run, April 22, 1889, when Stillwater mustered a handful of new residents, the town grew slowly and steadily to a current population of 45,000. So many changes occurred, but some things have stayed surprisingly the same. Downtown Stillwater has remained relatively within its original borders. While some of the buildings are still intact, the names of the shops, banks, and businesses have changed. While several shopping centers have been built recently (along Perkins Road, Main Street, Boomer Road, and West Sixth Avenue), downtown is currently going through its own revitalization. The most significant change is the arrival of new restaurants and wine bars. Debuting in 2014, several residential lofts are being finished out in many of the upper floors of the old downtown buildings. Back in the 1920s to the 1950s, the downtown area was busy, and cars jammed the streets. The same can be said today, as the shops, restaurants, and other businesses keep the area busy from morning until night.

Another major area of change has occurred on the campus of Oklahoma State University. When the Assembly Building, now know as Old Central, was built in 1895, it sat quietly alone on a prairie northwest of Stillwater. At the dedication, the president of OAMC promised more new permanent buildings, and that has turned out to be a huge understatement. Today, the campus consists of scores of buildings, dorms, apartments, barns, greenhouses, and offices. One of the most notable buildings on the campus would be the Student Union Building, erected in 1950. As the world's largest student union, it was the first to have its own shopping center and hotel. The recent refurbishment of the main building and the upcoming rehabilitation and remodeling of the attached Atherton Hotel will cost almost $100 million. The beautiful and stately Edmond Low Library is the focal point of the campus, while the newest and most talked about changes belong to the OSU athletic departments. In 1994, Karsten Creek Golf Course was built, and it became known as the top college course in the nation. Gallagher Hall, the school's basketball and wrestling home, was rebuilt and doubled the capacity to 13,611. This allowed the new Gallagher-Iba Arena to be declared by *Sports Illustrated* "the rowdiest arena in the country."

Next door, even bigger changes have occurred. With the help of T. Boone Pickens, a grateful Okie and OAMC alum, the refurbished Boone Pickens Stadium now holds over 60,000 enthusiastic Cowboys fans. His donation of almost half a billion dollars will ensure that OSU will continue to stay in the upper echelon of college sports. The OSU Athletics Department has earned over 50 national titles, the second most in the nation. Joining the new indoor/outdoor tennis complex, a new track-and-field center and a new equestrian center are being built, as is a new baseball stadium, which is to be constructed to minor-league standards. Nearby is the popular National Wrestling Hall of Fame.

Stillwater has had a library system almost since its inception. After moving in and out of residential buildings, it relocated to its longtime home at 206 West Sixth Avenue (above), which now houses the headquarters of Ocean Dental Company. It is shown below at its new location at Twelfth Avenue and Duck Street. This was the site of South High for the first part of the 20th century. (Both, author's collection.)

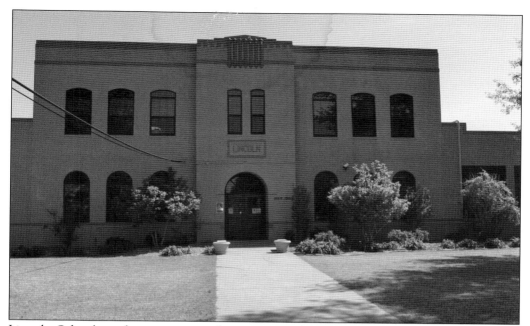

Lincoln School was home to many elementary students from the nearby neighborhood of Tuckertown and surrounding areas. It is now houses Lincoln Alternative Academy and the bus barn. (Author's collection.)

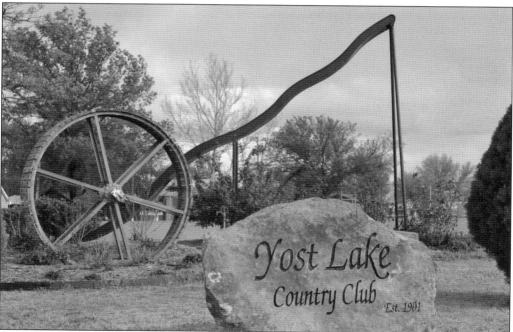

Yost Lake was a popular recreation spot for many years, starting in the early part of the 20th century. Through some ebbs and flows, it has once again attained its status as a fun and wholesome destination for many fortunate families. Today, there are 61 cabins, old and new, for families coming for the weekend or the summer. (Author's collection.)

Luckily, this is a sight not seen anymore. While there is still discrimination among different minorities, these KKK rallies are a thing of the past. Oftentimes, some of these hooded men were town leaders, although their identity was secret. There has never been any mention of Stillwater leaders being a part of this racist group.

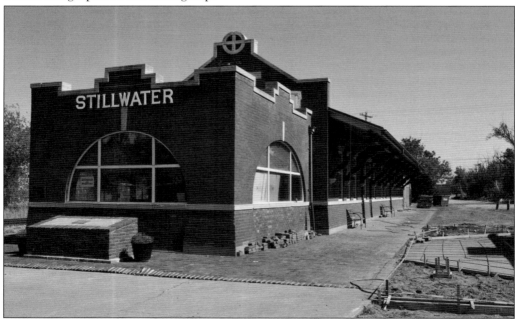

The Stillwater Railroad Depot was the answer to many a prayer in the early 1900s, as Stillwater was finding it hard to grow without train service. Today, the station at 400 East Tenth Avenue is the national headquarters for Tau Beta Sigma, a national honorary band sorority. It has been refurbished to its original condition. (Author's collection.)

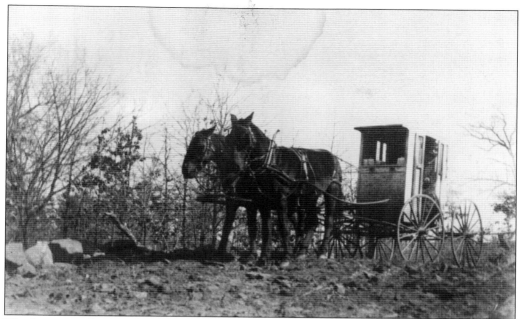

The first post office was actually just a mail wagon that ran from the Sac and Fox Indian Agency, north of Stroud (it later moved to the Pawnee Agency, which was much closer). This 1907 image is of Charles Ingersol on Postal Route 5, riding the rough terrain across Stillwater Creek and on to Mehan. Ingersol seems to be looking to see who might be photographing him.

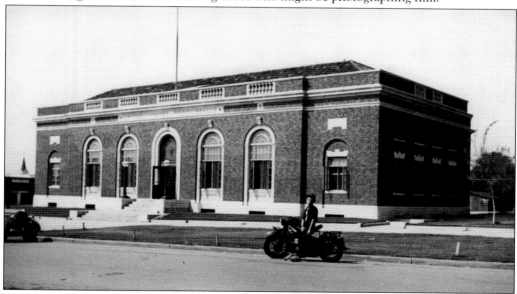

The post office moved to six various buildings along Main Street for many years, starting at the Swiler General Store at Thirteenth Avenue and Main Street. It would be 44 years before Stillwater would build its first permanent post office at 720 South Husband Street. It remained in this building until 1980 before moving to more modern surroundings a few blocks east at 809 South Lewis Street. This photograph, taken before additions built to the north, shows the new home of the Oklahoma State University Art Museum on South Husband Street.

The first thing town leaders must decide on is where to build the town hall. Stillwater's first was located in the Swope Building at the northwest corner of Ninth Avenue and Main Street. After several moves, this Art Deco building, erected in 1939, has served the town well for 75 years. The Art Deco Municipal Building may be hard to spot, having become an unfortunate victim of remodeling that covered it with stucco and thus removed its Art Deco features. In front of the new addition to the left of the original building is the garden named for Stillwater mayor Mrs. Mike Henson.

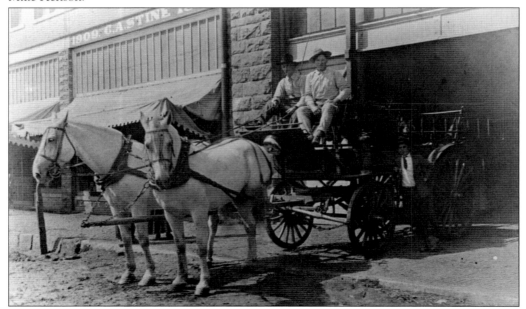

Stillwater's first fire-prevention equipment included a wagon and borrowed horses from the Myer's Livery across the street. The department obtained its own horses for a short time before the arrival of fire trucks.

Stillwater's first hospital was in the home of Dr. Whittenberg, but it eventually moved into this "modern" facility at Ninth Avenue and Walnut Street. This served the town from 1939 until 1976. This building was constructed in one month in order to qualify for federal aid. After demolition, this became the site of several medical buildings and pharmacies.

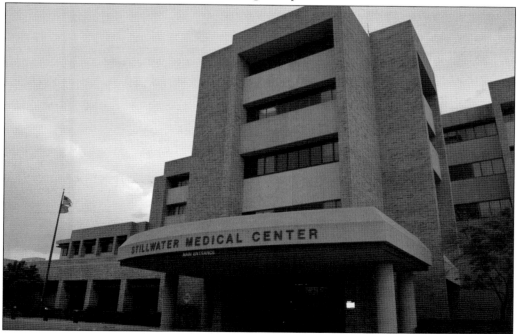

Today's hospital, Stillwater Medical Center at 1323 West Sixth Avenue, has become a major regional health care center for north central Oklahoma, employing more than 1,000 people. This facility was built in 1976 and has been added to several times to meet the needs of the growing town and aging population. (Author's collection.)

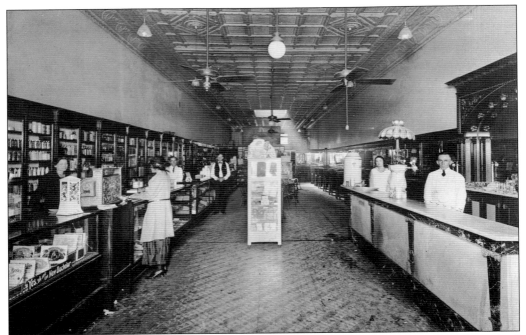

Tiger Drug Store, located at 706 South Main Street, was a popular spot, serving not only medical needs but also functioning as a soda fountain and hangout for A&M students. Dances were often held next door at Katz Hall, and students would flock to Tiger Drug afterward for a root beer float or other treats. Jesse Peak is the pharmacist, in the white jacket; the manager is wearing the vest. Although the soda fountain is long gone, Tiger Drug is still a popular pharmacy after moving to 824 South Walnut Avenue, a site on the grounds of the longtime hospital. The name, Tiger Drug, may be the last vestige representing the original team name of Oklahoma A&M College, the Tigers. Neal Khonke, the pharmacist in white below, stands ready to serve. (Both, author's collection.)

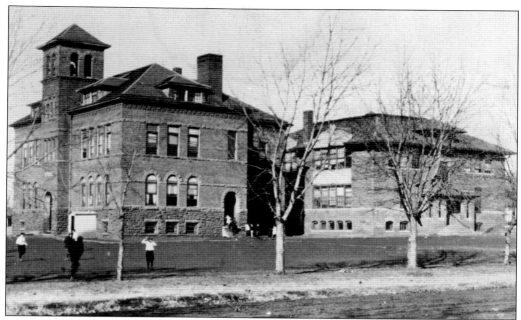

These were the first two schools built for the new town after the original school was held in the Swope Building at Ninth Avenue and Main Street. Alcott School, at left, was built in 1896, followed by Horace Mann in 1910. This storied site became the home of the new junior high school and today is the home of the Stillwater Community Center and the Winfrey D. Houston Theater.

The new high school, at 1224 North Husband Street at Boomer Road, was built in the late 1960s. It was named in honor of school board member C.E. Donart until 1980 and is now known as Stillwater High School. It has had several additions, and a new football stadium has just been built on the campus, replacing Hamilton Field in Couch Park. (Author's collection.)

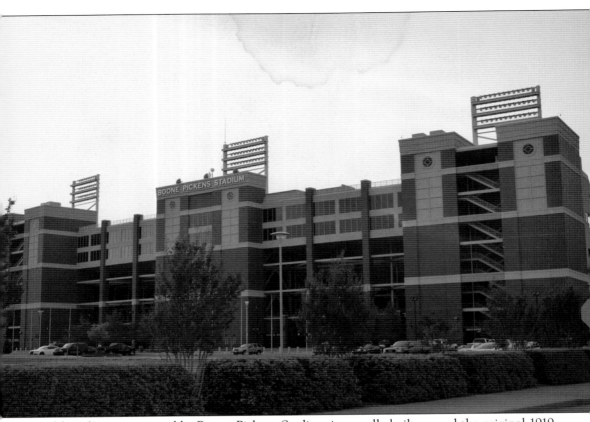

Although not recognizable, Boone Pickens Stadium is actually built around the original 1919 stadium, making it the oldest major college football stadium west of the Mississippi. Lewis Field was built in 1901 but moved to its current location in 1916, with the stadium being built three years later. Named for the dean of veterinary medicine and science and literature, Lewis Field served the university for 90 years until it was rededicated and christened as Boone Pickens Stadium. Thanks to the generosity of a proud and grateful Okie (and an OAMC graduate), T. Boone Pickens from Holdenville, Oklahoma, OSU now has a first-class stadium that boasts 60,218 seats, with 3,500 club seats and 111 luxury suites, with some able to view the football stadium and the historic Gallagher-Iba Arena.

This was the first location of Oklahoma A&M College, starting in 1891. Classes were held in the Congregational church until Old Central, then known as the Assembly Building, was erected in 1894. This was the first church in Stillwater, built at the northwest corner of Duncan Street and Sixth Avenue. Today, the sprawling campus of OSU boasts hundreds of classrooms, apartments, offices, dormitory rooms, and laboratories and is home to approximately 25,000 students.

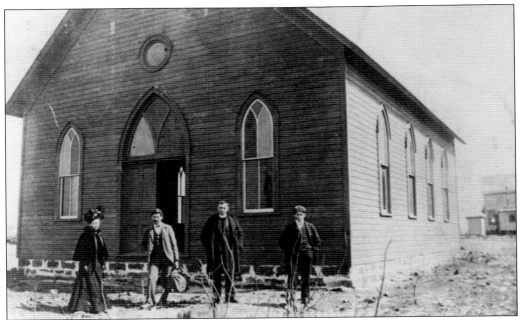

Without a large Catholic population, Stillwater did not have a diocese or a bishop. Before Stillwater Catholics had their own building, they were served by Fr. Felix de Grasse, who came from the monastery in Sacred Heart, Oklahoma, located 82 miles south on the Pottawatomie Reservation. The Catholics then became a part of the Perry Mission. The above photograph shows the first Catholic church, with Fr. John Heiring, third from left, serving as the first priest. This church, at Sixth Avenue and West Street, cost parishioners $600. The below photograph shows the current St. Francis Catholic Church. (Both, author's collection.)

The first church to be organized in Stillwater was the Methodist congregation. Shortly after the 1889 land run, they met on the second floor of Amon Swope's building at Ninth Avenue and Main Street. After the Congregational church was built, the Methodists built their first church building in 1892 at the southeast corner of Eighth Avenue and Duncan Street. Their first minister was J.W. Hubbard. The below photograph shows the church today, built in Italian Renaissance style at 400 West Seventh Avenue. Although there have been several renovations and additions of classroom space, this church, constructed in 1923, retains most of its original glory. (Below, author's collection.)

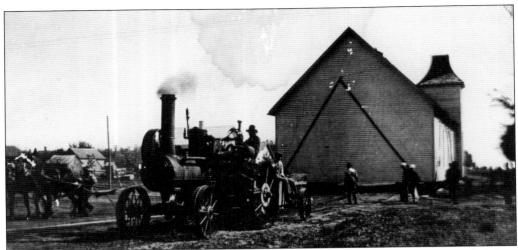

It was common in early territorial towns for the town leaders to assign lots to the various churches, usually just outside the downtown area. The Presbyterians were given lots at the corner of Sixth Avenue and Duncan Street. After building their first church, the members considered it too far out and in the boonies. They loaded their building on a wagon and moved it to two lots they had just bought for $70. After a few years, they wanted more room and moved back to the familiar corner of Sixth and Duncan.

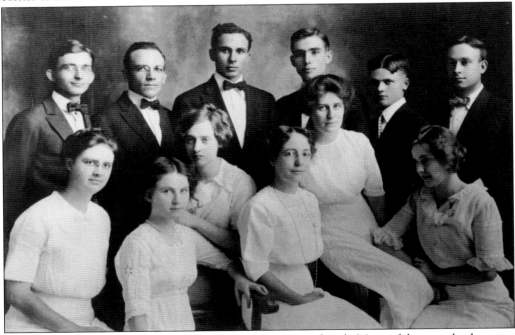

As early as 1910, the Presbyterians were a large and growing church. Many of the town leaders were members, as represented in this photograph of the Presbyterian choir. The women are, from left to right, Emma Bassler, Fearn Hamilton (daughter of Seth Hamilton), Jean Jones, Carrie Bullen, Ruth Lahman, and Ruth Fuller. The men are, from left to right, Harold Peck (owner of OAMC hangout Pecks Lodge), Ray Moore (whose father established Stillwater Savings), Loyal Miller, E.J. Smith, Frank Melton, and C.E. Donart (namesake of the high school built in 1960).

The current Presbyterian church, erected in 1924, is of Gothic Revival architecture, a popular style for churches built in the 1920s. Winfrey Houston, writer of the foreword to this book, and his family have been longtime members. Many other churches have been an integral part of the early days of Stillwater. Other downtown churches included First Methodist, Congregational, First Baptist, Church of Christ, Christian Science, Salem Evangelical Lutheran, First Christian and United Brethren. Surrounding churches were Assembly of God, Calvary Baptist, Church of God, First Nazarene, St. Andrew's Episcopal, St. Francis Catholic, Stillwater Gospel, Stillwater Mission, and Zion Lutheran, among many others built to serve the spiritual needs of Stillwater residents. (Author's collection.)

Before the 1950s, it was rare to see women driving automobiles. Florence Severson bucked the trend and proudly drove her new 1938 Studebaker around town. An English and journalism teacher at South High, she is known as the teacher who rekindled interest in the yearbook, *The Bronze and Blue* (the school colors for the Stillwater Pioneers).

Ralph Hamilton (second row, center), for whom the Pioneers' former football stadium in Couch Park is named, stands with his 1931 basketball team. He was known as a tough coach, and students were very fond of him. Max Hansen (far right) was quoted as saying, "He carried a barrel stave to football practice and whacked the running backs to make them move faster."

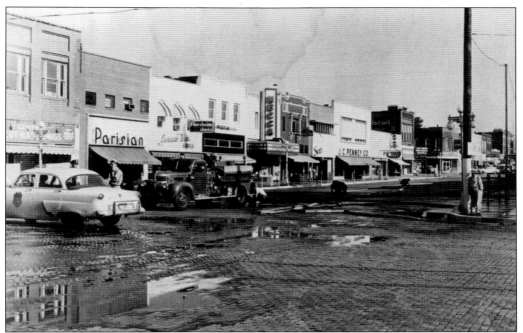

This photograph, taken in the early 1950s, shows the west side of the 700 block of South Main Street. Popular stores of the day, from left to right, are Central Drug, the Parisian, Earnest Brothers Shoes, the Mecca Theater, and J.C. Penney.

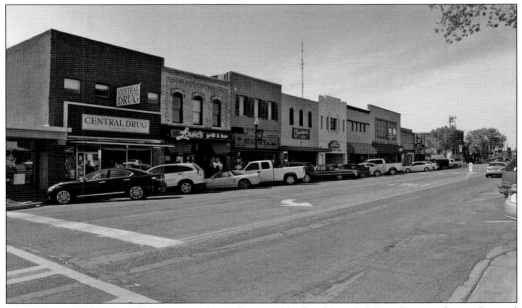

This photograph, also of the west side of the 700 block of South Main Street, shows Central Drug next to its original location; all the other stores have changed hands. From left to right are Louie's Grill, the Beadery, Flannigan's, Rocky Mountain Chocolate, and Kinsington Mall, with the iconic Leonard Jewelers, anchored at the north end of the block by a new downtown location of the popular Red Rock Deli. (Author's collection.)

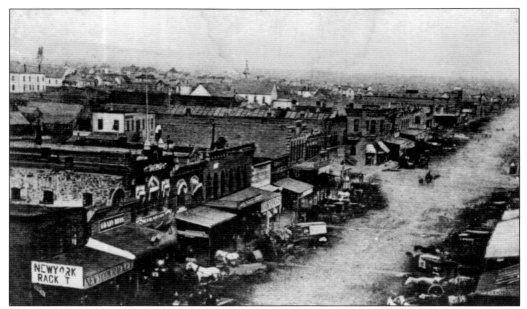

This c. 1909 photograph shows the west side of the 800 block of South Main Street. Amon Swope's building, which housed the first bank, church, and school, gave way to the New York Racket Store sitting on the corner. Along the block also sit Grady Bothers Jewelry and Sam Miller's Department Store. The white frame building at upper center is the county's second courthouse. Houses seem to surround the northwest suburb.

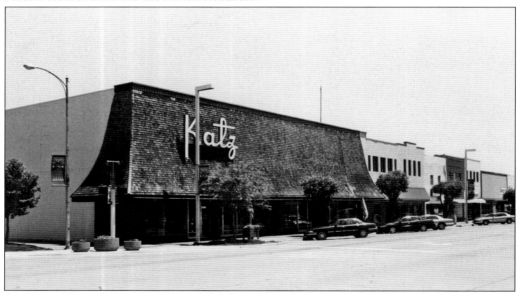

Since 1894, Katz Department Store served the citizens of Payne County for over 100 years. Starting on the west side of Main Street, it moved to its long-time home at 707 South Main Street. This photograph shows the remodeled version that many remember; it closed in the 1990s. The building has been restored, removing this 1980s Mansard roof, and is now home to Brooklyn's restaurant. The original Katz sign is in the basement's wine bar, and the iconic round sofa that sat at the front door for many years was donated to the Sheerar Museum.

Big changes have occurred on both sides of the 800 block of South Main Street. The iconic Stillwater National Bank abandoned its large brick structure at the southwest corner of Eighth Avenue and Main Street. It was demolished for the generic-looking Eight Main Place, much to the chagrin of preservationists. Across the street, First National Bank's imposing structure was torn down to make way for a more modern, yet sterile, building.

This 1954 photograph, along the 700 block of South Main Street, features the popular F.W. Woolworth, one of several variety stores downtown (others included TG&Y and McLellan's). These stores eventually gave way to the much larger Walmart built on Perkins Road, beginning the influx of businesses from downtown to strip centers around town. To save downtown, a committee even considered turning the area into a covered mall.

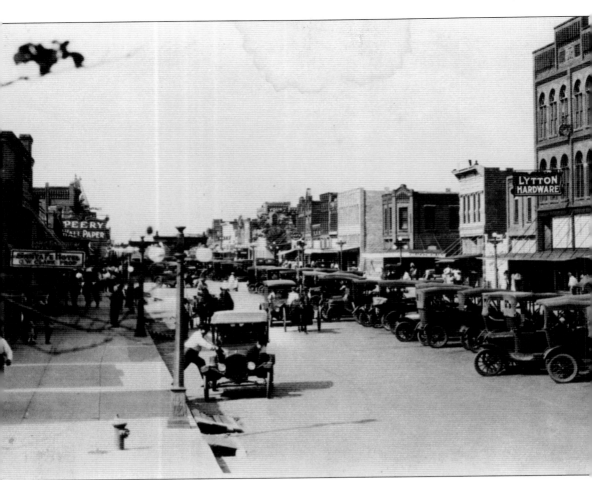

Automobiles have replaced horses and wagons along this stretch of the 900 block of South Main Street. In the absence of horses, the hitching posts have all been removed, and streetlights have been installed. Lytton Hardware, a popular destination for those in need of home goods and hardware, sits on the west side, while Peery Wall Paper and the Santa Fe Hotel are on the east side.

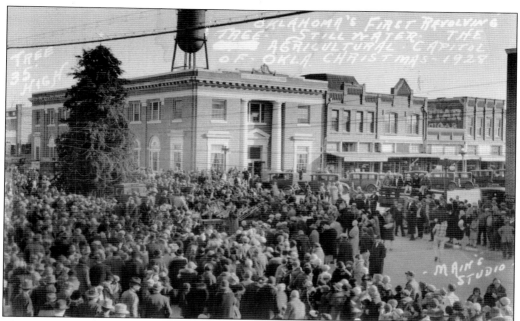

This photograph, taken in 1928, shows the excitement of downtown Stillwater's revolving Christmas tree. To the left of the tree, the postcard says that the tree is 35 feet tall. To the left of the water tower, the card reads, "Oklahoma's first revolving tree. Stillwater, agricultural capital of Oklahoma. Christmas 1928." Stillwater National Bank is prominent in the image. (Author's collection.)

Many women today may take umbrage to this advertisement for the Aggiette Wave Shop, proclaiming that "Beauty is a Woman's Duty." Although she cannot get her hair cut here at the Aggiette, named for the college's athletic teams, a woman can get her hair "shaped."

AGGIETTE
Wave Shop

"Beauty Is a Woman's Duty"

- Merle Norman Cosmetics
- Permanents
- Parker-Herbex Scalp Treatments
- Revlon Manicures
- Hair Shaping
- Steam Bath & Body Massage

122 Duck Street **Telephone 263**

Winfrey Houston, who wrote the foreword to this book, was born in Stillwater in 1926 and never left. His love of Stillwater and desire to keep its history alive was evident with his purchase of this block of buildings at Seventh Avenue and Husband Street. He painstakingly restored the 1910s buildings to their original glory. The buildings are now listed in the National Register of Historic Places. (Author's collection.)

Stillwater was growing and needed a larger police presence. The force in 1949 included 18 officers. Here, Mayor A.B. Abbott (lower left) and Judge Tony Higgins (lower right) pose with the police force. Glenn Shirley is directly behind the mayor in the third row. It is thought that Joe Manual (third row, center) was the city's first black policeman. (Author's collection.)

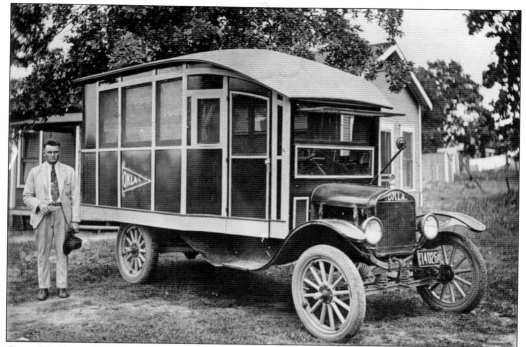

One of Stillwater's most popular fall pastimes is tailgating at the Oklahoma State University Cowboy football games. People drive from every direction to set up elaborate tailgates, including outdoor kitchens, large-screen televisions, and super-sized motor homes. This was said to be the first motor home, and it featured amenities such as curtains, a table, and even a primitive bathroom.

Today, most retail transactions rely on credit cards, debit cards, or personal checks. From the early days through the 1960s, counter checks were the norm. Customers just grabbed a blank check, wrote the name of the bank, and signed it. It was a time when shopkeepers knew and trusted customers more. This counter check, signed by the author's father, is from the popular Katz Department Store at 707 South Main Street. (Author's collection.)

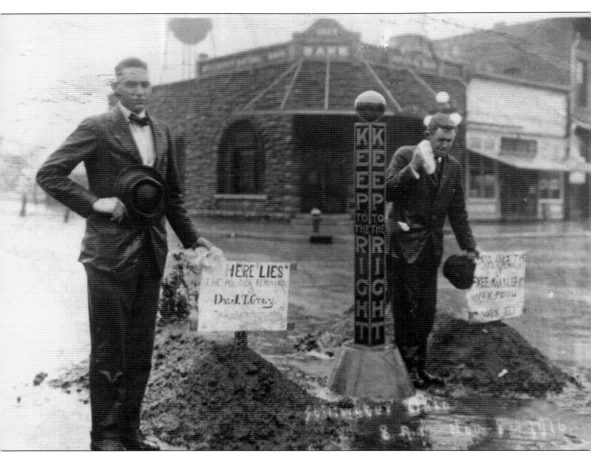

It seems one thing that has not changed is dirty politics. Here, at the corner of Ninth Avenue and Main Street in 1916, is a political demonstration. The sign says, "Here lies the political remains of David T. Gray." Stillwater has had its share of political figures. James Berry served as lieutenant governor from 1935 to 1955, under five governors, beginning with the popular governor E.W. Marland of Ponca City. Keeping his home on Duck Street, he commuted to the state capital for 20 years. Henry Bellmon, an OAMC agronomy alum, was elected Oklahoma's 18th and first Republican governor in 1963. He then served as US senator for 12 years before returning as the 23rd governor from 1986 to 1990. He served as Richard Nixon's national campaign chairman and was with him the day he resigned due to the Watergate scandal. Other OSU alumni, Frank Lucas (US representative from 1994 to the present) and Mary Fallin (current governor) must take a back seat when it comes to political national notoriety. Anita Hill, OSU alumna from Lone Tree, Oklahoma, catapulted into the national spotlight after her sexual harassment allegations against Supreme Court nominee Clarence Thomas in 1991.

After World War II and the economic expansion, more and more people began buying cars. The next transition in the movie business was to build drive-in theaters, taking advantage of the young, more mobile population. The Moonlite at 515 North Main Street was the city's first, opening in 1949. While drive-ins have been making a comeback, the closest to Stillwater is in Tulsa at the Admiral Twin.

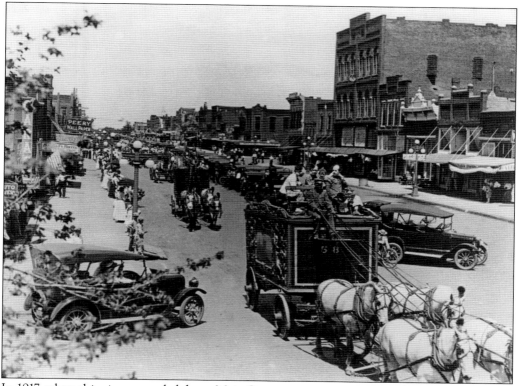

In 1917, when this circus paraded down Main Street to announce its arrival, excitement soared. While there are still circuses around, many now find that the larger amusement parks are more to their liking. Most citizens travel to Oklahoma City for Frontier City, Dallas/Fort Worth to enjoy the rides and attractions at Six Flags Over Texas, and, more recently, Silver Dollar City in Branson, Missouri.

Campus Corner may look drastically different, but if one looks closely, there is the distinguishing feature of the "Knoblock jog," where Knoblock and University Avenues intersect. This photograph, taken from the east side of Old Central, is looking south down Knoblock Avenue. The homes along the street have been replaced by Pecks Lodge, which houses Pecks Lodge Gifts, Wooden Nickel, and various other shops. The west side of the street now has Hideaway Pizza, the oldest existing restaurant in Stillwater (established in 1957), Elizabeth's, and Chris' University Spirit.

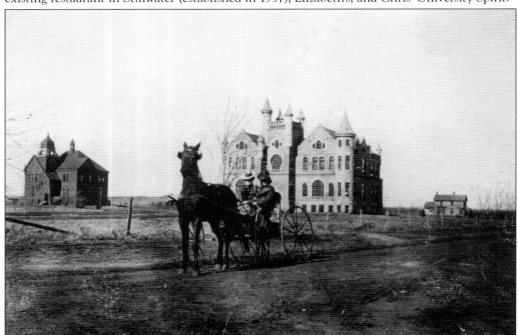

The Oklahoma Territory Agricultural & Mechanical College's barren campus looks void of any students except for the two taking a buggy ride around Old Central and Williams Hall. Today, with over 25,000 on-campus students, it would be rare to not see people at all times of day or night.

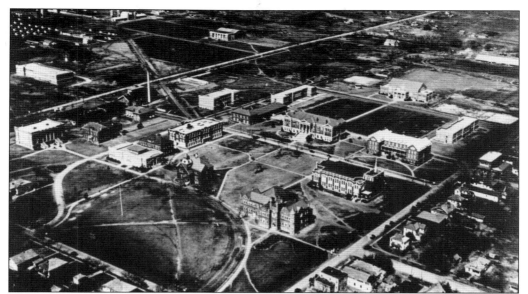

By 1926, the campus was taking shape. Several recognizable buildings can be seen here, including Old Central and Williams Hall in the foreground. Morrill Hall sits in the center, with Thatcher, the girls' dorm, and Hanner Hall, the boys' dorm, on either end of the parade fields. Behind them is the armory, now housing the OSU Architecture Department. Noticeably missing are the Edmond Low Library, Student Union, and the football stadium. A small set of bleachers (upper right) served the Tiger football team for several years.

This 1988 photograph shows the changes that have been made. The Edmond Low Library sits in the center, with the Student Union at the left. The "Union," as it is known, was built in 1949 with bowling alleys, game room, a shopping mall, several restaurants, and a hotel, and is still the world's largest. With the expenditure of over $100 million, it has been completely modernized and brought up to today's standards. The luxurious Atherton Hotel is a member of Historic Hotels of America.

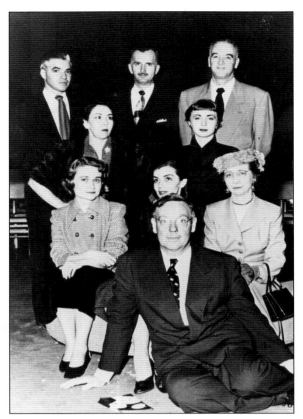

The name Town & Gown is a play on the concept of locals (town) and college students (gown) coming together for their mutual love of theater. Stillwater's Town & Gown is the second-longest-running theater in the state, celebrating its 62nd continuous year of productions in 2014. The first production, with the cast seen here, was *The Constant Wife* in 1952. The theater left the Oklahoma State University Student Union in 1962, and its current home at 3524 South Perkins Road can be seen in the photograph below. Among the locals, actor James Marsden, born in Stillwater in 1973, and OSU alum and Academy Award nominee Gary Busey both went on to Hollywood fame. (Both, author's collection.)

Pleasant Valley School was built to serve students that lived in the area two miles southwest of town. Standing at Nineteenth Avenue (formally Pleasant Valley Road) and Sangre Road, the school looks much like it did when it was built in 1899. Land for the new facility was sold to the board of education for $5 by landowner John Zuck. The school was built to serve up to 60 students (ranging from 5 to 19 years old) per year. It served the community until 1941. After 10 years of nonuse, the school and its land were deeded back to the original owner in 1951. For many years, it was used for church services, box socials, and pie suppers. The City of Stillwater bought the land for a new power substation in 1987, and the school was scheduled to be moved to the Harn Homestead in Oklahoma City. However, preservationists, led by Gary Oberlender, went to great lengths to see that it remained in its original location. After enduring hard-fought battles and raising the necessary money, they prevailed, and the school still sits where it was built in 1899. Today, it has been completely restored and is used as a "living history" school, coordinated by Carolyn Confer. Students from the area dress in period clothing and are taught the manner and subject of territory days: 1899 to 1907, the year Oklahoma joined the Union, becoming the 46th state. (Author's collection.)

Discover Thousands of Local History Books Featuring Millions of Vintage Images

Arcadia Publishing, the leading local history publisher in the United States, is committed to making history accessible and meaningful through publishing books that celebrate and preserve the heritage of America's people and places.

Find more books like this at
www.arcadiapublishing.com

Search for your hometown history, your old
stomping grounds, and even your favorite sports team.